MW00563050

# A FIRESIDE BOOK

## PUBLISHED BY SIMON & SCHUSTER
### NEW YORK • LONDON • TORONTO • SYDNEY • SINGAPORE

# MARK KISTLER'S
# Web Wizards!

Build Your Own Homepage with Public TV's Favorite Cybercartoonist and His Pal Webmaster Dennis

## MARK KISTLER AND DENNIS DAWSON

FIRESIDE
Rockefeller Center
1230 Avenue of the Americas
New York, NY 10020

Designed by Barbara M. Bachman

Manufactured in the United States of America

1 3 5 7 9 10 8 6 4 2

Library of Congress Cataloging-in-Publication Data
Kistler, Mark.
Mark Kistler's web wizards! : build your home page
with public TV's favorite cybercartoonist and his pal
Webmaster Dennis / Mark Kistler, Dennis Dawson.
        p.      cm.
1. Web sites—Design. I. Dawson, Dennis. II. Title.
            TK5105.888.K57 2000
    005.7'2—dc21                    00-020838
            ISBN 0-684-86322-7

# ACKNOWLEDGMENTS

Tremendous thanks are due to the amazing creative talent of the crew of *Mark Kistler's Imagination Station* Public Television series, many of whom have volunteered hundreds of hours to make the dream a reality. Robert Neustadt, Stephen Kistler, Dennis Dawson, Doug DeVore, Linda Griffis, Kim Solga, Red Grammer, Dan Cantrell, Arman Matin, Natalia Saenko, Jamie Cope, Jamie Pilarski, Maryann Colandrea, and the production crew of KNME Albuquerque Public Television.

**–M.K.**

If I see any success at all, it's because I've been given a boost by a group of good friends (strong ones, too).

Steven Dantzer is my partner at Enlightened Path Communications (www.epcomm.com). While I sit around making pretty pages, he handles the deep technical stuff and the business stuff. He helped me, gee, I don't know, buy the computer and have a Web business so that I could, gosh, know something and, shucks, write this book.

Douglas DeVore is a longtime video collaboration buddy of mine. He's the co-producer of the Web Wizards video segments for the Public Television show *Mark Kistler's Imagination Station* (which he also directed), and he had a lot to do with helping to create the myth that is Webmaster Dennis.

My wife Judy, daughter Emily, and son Casey put up with a lot of weekends at home while I wrote the book, and I appreciate their patience.

Special thanks go out to Miss McKinley's sixth grade class at Sedgwick School in Cupertino, California for helping me try out many of the exercises in this book. I also received help from the Sedgwick Internet Club. Thanks kids!

Amanda
Amna
Angela
Anthony
Antrom
Ashley
Charles
Chris
Daniel
Diana
Emily
Emily
Emma
Genna
Gregory
Hillary
Irene
Jaeun
Jarratt
Jonathan

Justin
Kelly
Korissa
Lisa
Marta
Matt
Pamela
Prajakta
Randy
Reeta
Solomon
Steven
Thanh-Truc
Tim
Tracey
Trixia
Wesley
Yu-Xuan
Zain

**–D.D.**

To my brother Stephen Kistler for holding all the pieces

of the "Imagination Station" together.

**–M.K.**

This book is dedicated to my short alphabetical list of balanced-brained buddies.

Thanks for exercising both halves of my head:

Betsy, Dale, Deborah, Doug, Gail, Jason, Linda, Lynne, Mark, Matthew, Rik, Steve.

**–D.D.**

# Contents

## 1. creating your first web page 12

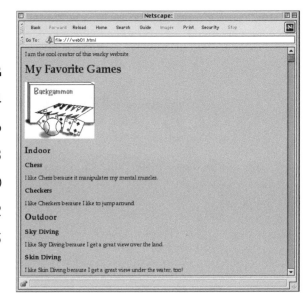

## 2. creating your personal homepage 26

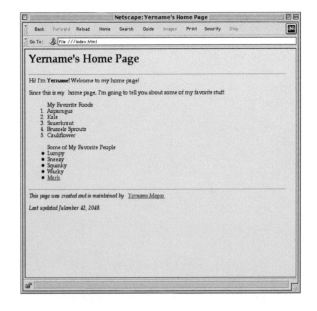

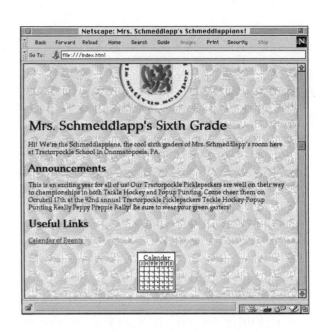

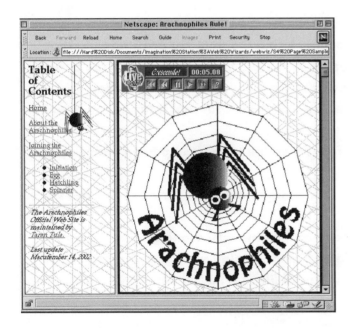

# Safe-Surfing Contract

**I, the undersigned,** do hereby agree that surfing the Internet is a privilege subject to certain rules, and I agree to live by those rules.

1) I will treat the Internet like a public park. While most people are nice and deserve to be treated with courtesy and respect, I know that there are also some people on the Internet who may try to hurt me or take something from me. I will be careful of strangers, and if anything anyone says or does makes me uncomfortable, I will immediately tell an adult whom I trust.

2) I will be a good Net citizen. I will not do anything to be mean or hurtful to anyone else on the Internet, and I won't put up with people being mean to me or using language I don't like. In those cases, I will log off or move on to a web site that suits me better.

3) I will not give out my last name, city, phone number, or any other information that will enable someone to figure out where I live. If anyone asks for that information, I will immediately tell my parents.

4) I agree to get my parents' permission before I arrange to meet in person with anyone I've met over the Internet.

5) I will obey surfing rules set by my parents regarding how much time I spend Net surfing and what sites I am allowed to visit.

6) I understand that there is a great big cyberworld online, just waiting to be explored. I also understand that there are sunny days, friends to play with, drawings to be created, and chores to be done, and that a balanced life is a happy life.

_____

**Web Wizard Apprentice**

_____

**Date**

# Welcome, O Wondrous Web Wizard Wannabe!

**So, you've come seeking the wisdom of the great and powerful Webmaster Dennis?** Excellent! You will begin your apprenticeship shortly. One thing is absolutely certain—you can create your own Internet web pages. I'll show you how to create cool web sites for yourself, your school, your club, your hobbies, your church, your grandma, your dog, your alien friend O'ooA'ork from the planet Gloob who lives under the dirty socks in your closet (ew!), anything you want.

Here's what you have to know before you get started: You need to have access to a computer, and you need to be able to create and save a text file (if you can't, turn to Sorcerers' Appendix B). It will be more fun if you know how to use a painting program, too, but you can use the cool artwork from the www.draw3d.com web site to practice until you learn to make your own pictures. If you want people to be able to see your web pages on the Internet, you will need to sign up for an Internet service or work with a friend who has access to the Net. Once you can surf the Internet, there are many services that will allow you to create a homepage free of charge. Your own Internet provider, in fact, might provide you with a space for your web page as part of your contract. If you need help getting started with your computer, or with finding a place to store your web site, ask your parents or a teacher to assist you.

Now, so that you'll recognize them and be able to follow them once we get started, here's how I'll be giving you instructions. When I want you to type something, I'll let you know by writing it like this:

-------------------------------------------------------------------------------

   Type **Mark Kistler is the coolest guy in the world.**

-------------------------------------------------------------------------------

Then, when I say "press RETURN," I mean that you should press the RETURN key (on a Macintosh) or the ENTER key (on a PC). It happens, my pupil, that I'm a dyed-in-the-wool Macintosh aficionado, but it doesn't matter what kind of computer you use. With either a PC-compatible or a Mac, you'll still be able to create web pages that people can view on any computer that runs Netscape Navigator or Microsoft Internet Explorer.

**So, are you ready for some cyberfun? Let's go make some magic!**

# I. Creating Your First Web Page

Let's start off with a bang! Creating web pages is a snap, and I'm going to show you just how easy it is in this first lesson. You're going to type a couple of sentences, and whoosh-bang, you've got a web site!

First, we need to add the HTML tags to tell the browser that this is an HTML page. So . . .

---

## I'm Techno Termite!

Whenever we come across a new word that you may not have heard before, I'll tell you what it means.

**Internet Browser** A browser is a program like Netscape Navigator or Microsoft Explorer that you use to look at words and text from the Internet.

**HTML** HyperText Markup Language. "HyperText" is words or phrases that you can click to read more about something. "Markup" is a term borrowed from newspaper editors, who use blue pencils to write instructions on—"mark up"—copy that tell the printers how a page should look. We do much the same on the computer: the HyperText Markup Language is the set of instructions you use to tell a web browser, like Netscape, how a page should look.

**Tag** A tag is a single instruction in HTML that describes how part of the page should look. Most tags come in pairs: one tells the browser when to start whatever it's supposed to do, and its partner tells the browser when the instruction is finished. These ending tags start with a slash (/). So, for example, when you start an HTML page, you use the tag <HTML>, and when you finish the page, you use the tag </HTML>.

### TO CREATE YOUR FIRST WEB PAGE

1) Open a new text file.
2) Type **<HTML>**.
3) Press **RETURN**.
4) Type **I am the cool creator of this wacky web site!**
5) Press **RETURN**.
6) Type **</HTML>**.
7) Save the file as web01.html. You don't have to close the file or quit your word processing program.
8) Open web01.html in your web browser.

Congratulations! You are a web author—you've created your first web page! The rest of the book will show you how to add cool things to your web page!

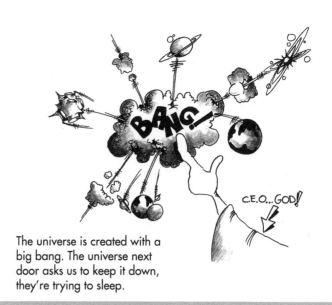

The universe is created with a big bang. The universe next door asks us to keep it down, they're trying to sleep.

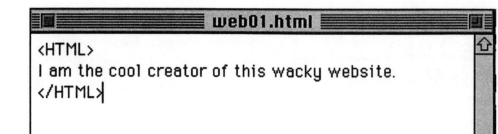

web01.html

```
<HTML>
I am the cool creator of this wacky website.
</HTML>
```

This is the HTML file you create . . .

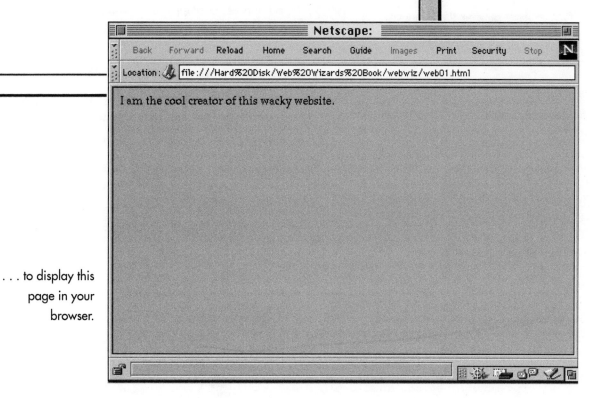

Netscape:

Back   Forward   Reload   Home   Search   Guide   Images   Print   Security   Stop

Location: file:///Hard%20Disk/Web%20Wizards%20Book/webwiz/web01.html

I am the cool creator of this wacky website.

. . . to display this page in your browser.

Webmaster Dennis is . . . born.

MAMA! I NEED A SHAVE!

Hi! I'm Biogopher!

I'll be telling you about people and events that were important in the development of communications. Many of the things I'll share with you will be true. Some will be conjecture (that is, horsefeathers).

# Adding <H1> Headings

Using heading tags, you can make your web pages easier to read and help people find the information they want more quickly.

---

Heading tags have six levels, from <H1> to <H6>. <H1> headings are the largest; headings get smaller until you reach <H6>. Headings let you organize the information on your web site into subcategories that share similar characteristics. (Headings let you separate the stuff on your page into clumps of stuff that's like other junk.)

## TO ADD <H1> HEADINGS TO YOUR WEB PAGE

1) Open web01.html in your text editor. (If you didn't close it, it should still be open.)

2) With your mouse, position your cursor at the end of the sentence "I am the cool creator of this wacky web site."

3) Press **RETURN**.

4) Type **<H1>My Favorite Games</H1>**.

5) Save web01.html.

6) Open web01.html with your web browser. (If your web browser is still showing your page, you can click the Reload or Refresh button.)

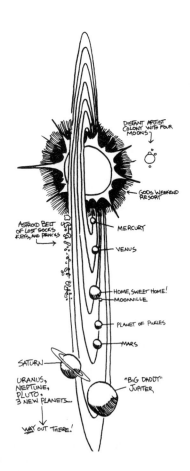

DISTANT ARTIST COLONY WITH FOUR MOONS

GODS WEEKEND RESORT

ASTROID BELT OF LOST SOCKS KEYS, AND PENCILS

MERCURY

VENUS

HOME, SWEET HOME!
MOONVILLE

PLANET OF PICKLES

MARS

SATURN

URANUS, NEPTUNE, PLUTO, 3 NEW PLANETS...

"BIG DADDY" JUPITER

WAY OUT THERE!

Our solar system is formed.

5,000,000,000 years ago

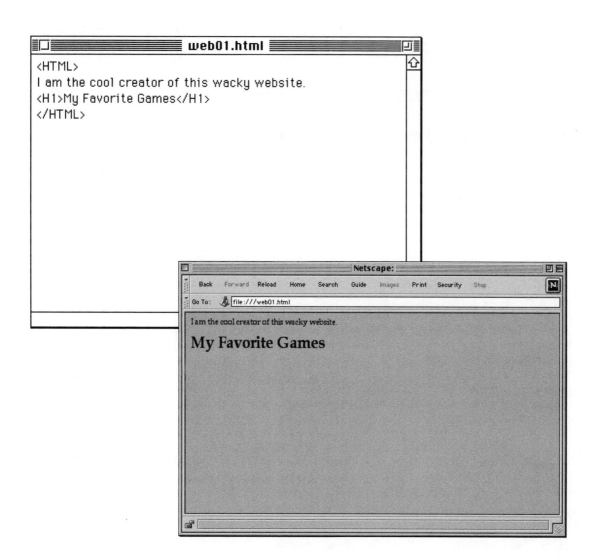

```
web01.html

<HTML>
I am the cool creator of this wacky website.
<H1>My Favorite Games</H1>
</HTML>
```

Netscape:

Back    Forward    Reload    Home    Search    Guide    Images    Print    Security    Stop

Go To: file:///web01.html

I am the cool creator of this wacky website.

# My Favorite Games

Hey, here's the first life story! Prokaryotes are thought by scientists to be the earliest cell life to evolve on Earth. They first appeared about two billion years ago, and include critters like bacteria and algae.

The moon is pelted by meteors. Demands a pay raise.

One prokaryote thinks another prokaryote looks cute . . .

3,000,000,000 years ago

2,000,000,000 years ago

# Adding <H2> Headings

The heading tags get smaller as you give more details about your subject. You use H2 headings to subordinate your topics ("sub," as in "under," and "ordinate" as in "putting them in order"), so you're organizing one heading under another in a particular order.

**TO ADD <H2> HEADINGS TO YOUR WEB PAGE**

1) Open web01.html in your text editor.
2) With your mouse, position your cursor at the end of the line "<H1>My Favorite Games</H1>."
3) Press **RETURN**.
4) Type **<H2>Indoor</H2>**.
5) Press **RETURN**.
6) Type **<H2>Outdoor</H2>**.
7) Save web01.html.
8) Open web01.html with your web browser.

Dinosaurs roam the Earth. Dinosaur moms call them home for dinner.

Drawersaurus: Hunts down prey, makes them pose for hours.

230,000,000 years ago                    100,000,000 years ago

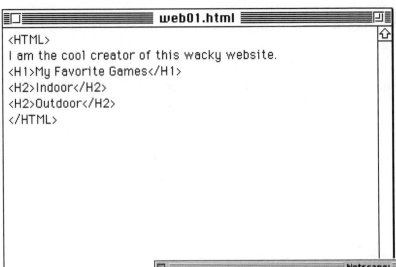

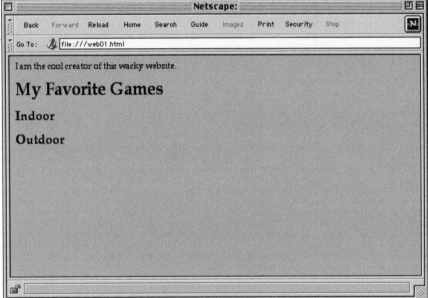

Kistlersaurus: Prefers cool, dark climates (shade, shade, shade—he loves the shade . . .).

Apes encounter a big black stone slab. Hit it with bones. Scratch themselves.

65,000,000 years ago

1,000,000 years ago

# Adding <H3> Headings and Details

Now we'll add the headings for specific games you enjoy, and you can say something about them.

---

**TO ADD <H3> HEADINGS TO YOUR WEB PAGE**

1) Open web01.html in your text editor.

2) Position your cursor at the end of the line <H2>Indoor</H2>.

3) Press **RETURN**.

4) Type **<H3>Chess</H3>** (or choose a different game you like, if you want to).

5) Press **RETURN**.

6) Type **I like Chess because it manipulates my mental muscles.**

7) Press **RETURN**.

8) Type **<H3>Checkers</H3>** (or some other game).

9) Press **RETURN**.

10) Type **I like Checkers because I like to jump around.**
(Too lame? Okay, make up your own witty sayings!)

11) Save web01.html.

12) Open web01.html with your web browser.

13) Extra credit: Make your page look like the example on page 19 by adding the outdoor games.

Rockell Wilch invents the prehistoric exploitation film, then invents the wheelbarrow to take home all the money she makes.

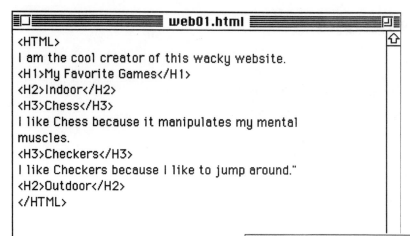

```
<HTML>
I am the cool creator of this wacky website.
<H1>My Favorite Games</H1>
<H2>Indoor</H2>
<H3>Chess</H3>
I like Chess because it manipulates my mental
muscles.
<H3>Checkers</H3>
I like Checkers because I like to jump around."
<H2>Outdoor</H2>
</HTML>
```

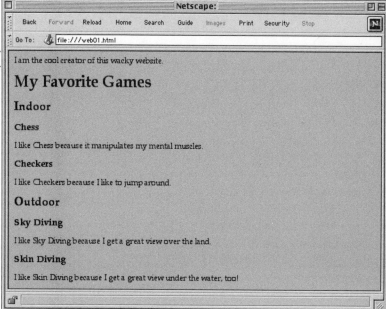

Man discovers fire.

500,000 B.C.

Zog the Troglodyte, 500,012 B.C.–499,983 B.C., discoverer of fire. Of course, fire had been around for a long time, but Zog figured out how to make his own. With fire, man could live in any climate, and people started moving all over the world. Zog also invented the first word: "ouch."

Man invents the wheel. Eons later, man invents the bucket seat.

50,000 B.C.

# Adding a Graphic Image Your Web Page

Originally, the Internet was used to share text (words) and couldn't display pictures, also called graphics. Since the early 1990s, though, graphical web browsers have become standard, and these let you include pictures, sound, and video clips, as well as words, on your web page.

## JPEGs and GIFs

There are two common graphic file types used on the Internet: JPEG and GIF. JPEG stands for the Joint Photographic Experts Group, the committee that decided how JPEG graphics would be encoded. JPEG graphics store color information for each dot in a picture. This allows for gradual color changes and makes JPEG a good choice for storing photographs and scanned images. JPEG files tend to be slightly larger than GIF files. GIF stands for Graphic Interchange Format, and saves storage space by encoding only the specific colors used in the picture. This makes it a good choice for pictures you draw using your computer. These are only general suggestions. Sometimes JPEG files can be smaller or GIF images clearer. You can also choose to save lower-quality JPEG images to make the files use less disk space. You may want to try saving the same picture in both formats and compare the results on your web page.

**TO ADD A GRAPHIC IMAGE TO YOUR WEB PAGE**

1)  Use a graphic of your own, or download one from www.draw3d.com.
2)  Copy your graphic to the same directory as your file web01.html.
3)  Open web01.html.
4)  Position your cursor at the end of the line <H1>My Favorite Games</H1>.
5)  Press **RETURN**.
6)  Type **<IMG SRC = "games.gif">**.
7)  Save web01.html.
8)  Open web01.html with your web browser.

Man begins to paint cave walls with bison, rhinoceroses, and mammoths. The beginning of writing.

35,000 B.C.

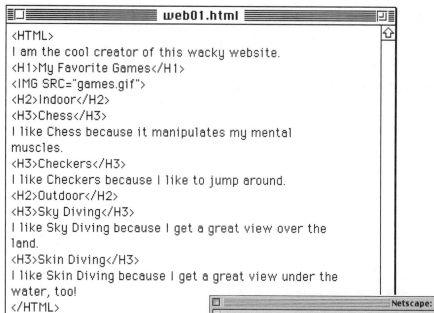

```
<HTML>
I am the cool creator of this wacky website.
<H1>My Favorite Games</H1>
<IMG SRC="games.gif">
<H2>Indoor</H2>
<H3>Chess</H3>
I like Chess because it manipulates my mental
muscles.
<H3>Checkers</H3>
I like Checkers because I like to jump around.
<H2>Outdoor</H2>
<H3>Sky Diving</H3>
I like Sky Diving because I get a great view over the
land.
<H3>Skin Diving</H3>
I like Skin Diving because I get a great view under the
water, too!
</HTML>
```

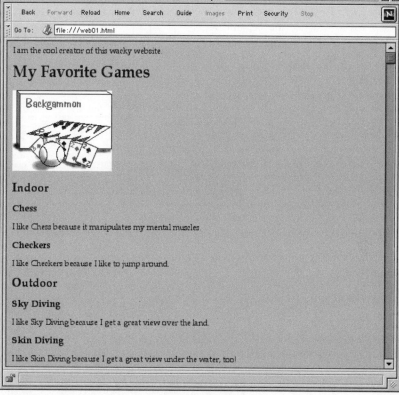

I am the cool creator of this wacky website.

# My Favorite Games

Backgammon

## Indoor

### Chess

I like Chess because it manipulates my mental muscles.

### Checkers

I like Checkers because I like to jump around.

## Outdoor

### Sky Diving

I like Sky Diving because I get a great view over the land.

### Skin Diving

I like Skin Diving because I get a great view under the water, too!

First Ice Age lowers the level of the world's oceans. The Bering Land Bridge connects Asia to North America. People flock across, looking for Disneyland.

24,000 B.C.

# Cool Sites!

You already know enough to create a pretty cool web site!
What can you do with just words and pictures?

--------------------------------------------------------------------------------

### *The Gutenberg Project (http://gutenberg.net)*

Can you make a cool site that has nothing but words on it?
You bet! The Gutenberg Project is a virtual library of some
of the greatest literature in the English language. Volunteers
spend hundreds of hours scanning or typing great books
that belong in the public domain (that means that copyright
protections have expired on the book and anyone can use

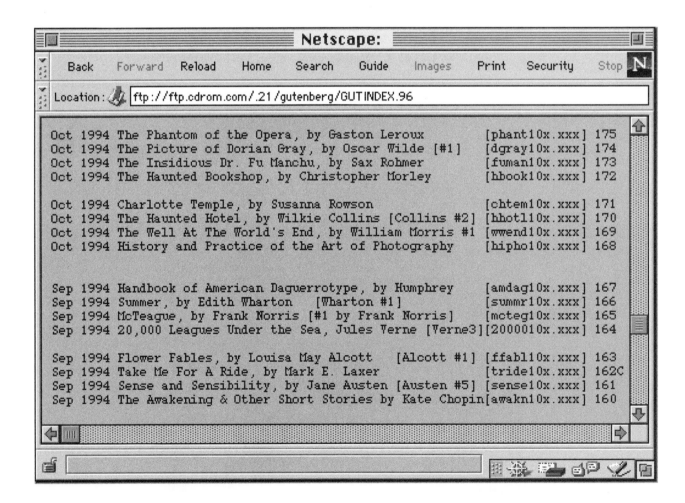

```
Netscape:

   Back   Forward   Reload   Home   Search   Guide   Images   Print   Security   Stop  N

Location: ftp://ftp.cdrom.com/.21/gutenberg/GUTINDEX.96

Oct 1994 The Phantom of the Opera, by Gaston Leroux            [phant10x.xxx] 175
Oct 1994 The Picture of Dorian Gray, by Oscar Wilde [#1]       [dgray10x.xxx] 174
Oct 1994 The Insidious Dr. Fu Manchu, by Sax Rohmer            [fuman10x.xxx] 173
Oct 1994 The Haunted Bookshop, by Christopher Morley           [hbook10x.xxx] 172

Oct 1994 Charlotte Temple, by Susanna Rowson                   [chtem10x.xxx] 171
Oct 1994 The Haunted Hotel, by Wilkie Collins [Collins #2]     [hhotl10x.xxx] 170
Oct 1994 The Well At The World's End, by William Morris #1     [wwend10x.xxx] 169
Oct 1994 History and Practice of the Art of Photography        [hipho10x.xxx] 168

Sep 1994 Handbook of American Daguerrotype, by Humphrey        [amdag10x.xxx] 167
Sep 1994 Summer, by Edith Wharton    [Wharton #1]              [summr10x.xxx] 166
Sep 1994 McTeague, by Frank Norris [#1 by Frank Norris]        [mcteg10x.xxx] 165
Sep 1994 20,000 Leagues Under the Sea, Jules Verne [Verne3][200001 0x.xxx] 164

Sep 1994 Flower Fables, by Louisa May Alcott     [Alcott #1]   [ffabl10x.xxx] 163
Sep 1994 Take Me For A Ride, by Mark E. Laxer                  [tride10x.xxx] 162C
Sep 1994 Sense and Sensibility, by Jane Austen [Austen #5]     [sense10x.xxx] 161
Sep 1994 The Awakening & Other Short Stories by Kate Chopin[awakn10x.xxx] 160
```

it or publish it) and makes them available via the web. The Gutenberg Project has no pictures on its web site, but through it you can travel to Treasure Island, buckle your swash with the Three Musketeers, or have thousands of other adventures just by downloading—for free—a copy of any of the books listed. There are thousands of books available, including a dictionary and an encyclopedia. The Gutenberg Project represents the best spirit of the Internet—getting information out into the hands of people around the world.

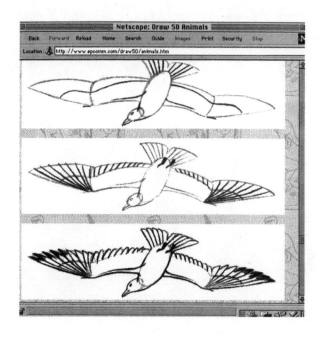

## Lee Ames's Draw 50 (www.draw50.com)

With a page of images, Lee Ames can teach you to draw animals, trains, people, or countless other pictures. Based on his perennially popular Draw 50 series of books, Lee's web site lets you sample his drawing lessons directly from the Internet.

# Cool Sites Continued

## Your Own Online Comic Strip

Do you like to draw? (Of course you do!) Do you like to tell stories? (Who doesn't?) You can put up your own art gallery, original stories, comic strips, anything you want! On your web site, you're your own publisher!

As soon as you create a picture, make up a story, or think of a joke, you can put it on a web page and immediately share it with the entire world! Don't be shy! You'll be amazed at how many people will want to see your work.

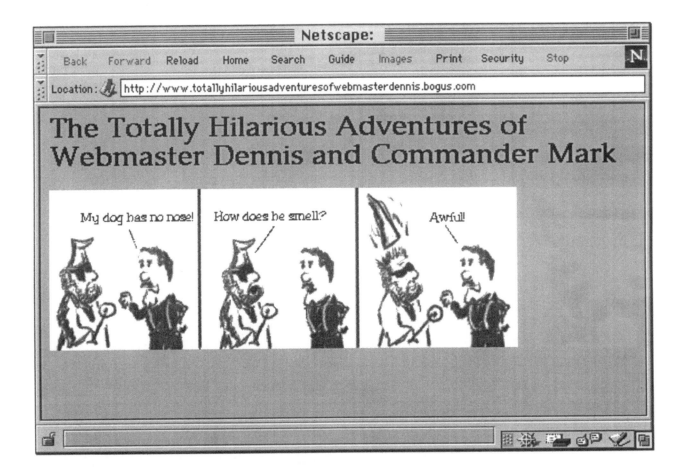

# What Have You Done?

You've created a simple web page with headings and a picture, you web-hacker you! That's most of the work you do on a web site!

Now you're ready to tackle the task of creating your first personal web page. We'll check out some ways to make your page look even cooler by placing words and pictures in a particular area of the page. You'll learn to make lists, and you'll learn how to link pages to hook up with your cyber-friends all over the world.

Let's go!

# 2. Creating Your Personal Homepage

You're now an official web wizard apprentice! Cool! The first thing to do is build yourself a cyber home. Your homepage is your starting point. It lets you express your own individuality on a world-wide network with millions of sites. Here's your chance to make your mark on the world! We'll start by putting your name in the title of the window.

**Hey, It's the Title Tag!**

**<TITLE> Tag**

The title tag tells the web browser what name should be at the top of the window when your page is displayed. The title should give some indication of what the page is about. Some network and Internet search programs use the title to guess at the kind of information a web page contains, and return titles when someone searches for information.

**safety tip**

Notice that only Yername's first name appears on the web page. Be careful not to give out too much information about yourself on the Internet. As with most folks in public places, Net surfers are mostly nice people, but there are some who are not so nice—so it's best not to reveal a whole lot. You can give your first name and state, but you'll be best off not to mention your city, the name of your school, or any other information that will enable a stranger to find you. It is important that you ask your parents to read your web page and help you decide what's right.

**TO CREATE YOUR PERSONAL HOMEPAGE**

1) Open a new text file.
2) Type **<HTML>**.
3) Press **RETURN**.
4) Type **</HTML>**.
5) Position your cursor in front of the </HTML> tag.
6) Type **<TITLE>Yername's Homepage </TITLE>**.*
7) Save the file as index.html.
8) Open index.html in your web browser: your title will appear in the title bar of the window.

*Don't even think of changing Yername to something else, like your name. Well, okay, you can if you want to . . . it's your homepage!*

The rise of the ancient Egyptian Empire, often called the Cradle of Civilization.

COOL... I AM KING, TODAY I DECLARE AS NATIONAL TWINKIE DAY!

Tutankhamen becomes pharaoh (king) in Egypt. He is often called the boy king, because he became pharaoh at the age of nine.

2500 B.C.                    1361 B.C.

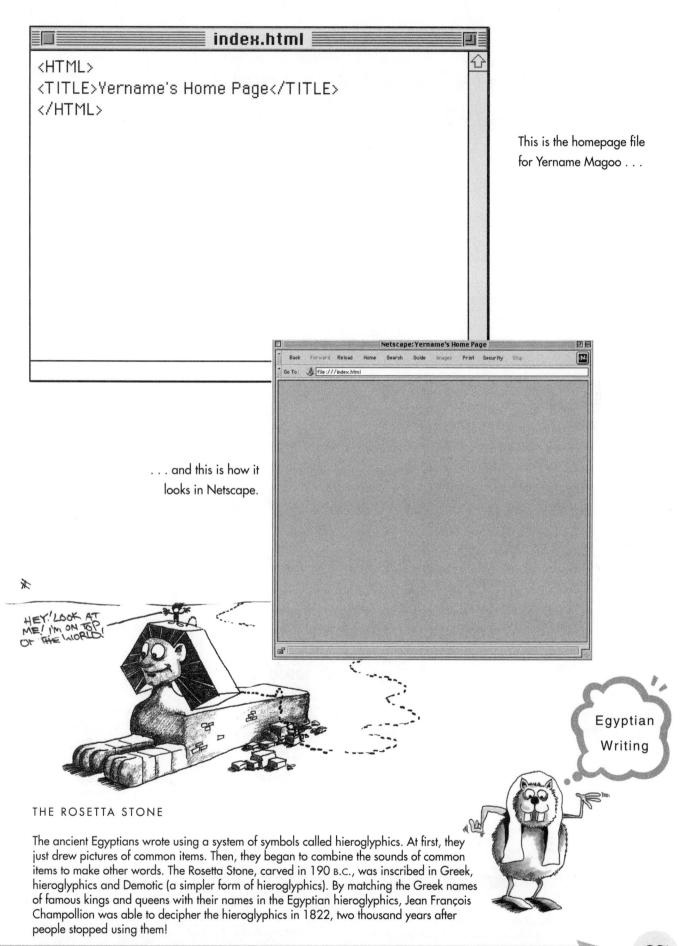

```
<HTML>
<TITLE>Yername's Home Page</TITLE>
</HTML>
```

This is the homepage file
for Yername Magoo . . .

. . . and this is how it
looks in Netscape.

HEY! LOOK AT
ME! I'M ON TOP
OF THE WORLD!

Egyptian
Writing

THE ROSETTA STONE

The ancient Egyptians wrote using a system of symbols called hieroglyphics. At first, they
just drew pictures of common items. Then, they began to combine the sounds of common
items to make other words. The Rosetta Stone, carved in 190 B.C., was inscribed in Greek,
hieroglyphics and Demotic (a simpler form of hieroglyphics). By matching the Greek names
of famous kings and queens with their names in the Egyptian hieroglyphics, Jean François
Champollion was able to decipher the hieroglyphics in 1822, two thousand years after
people stopped using them!

# The <BODY> Tag

The <BODY> tag was originally used to separate the content of a web page from the required header information that accompanies the file. Now the tag is optional: you use it to set special parameters for your entire page. We'll use it with the parameter BGCOLOR to change the page color.

---

## TO ADD A <BODY> TAG TO YOUR WEB PAGE

1) Open index.html in your text editor.
2) Position your cursor after the <HTML> tag.
3) Press **RETURN**.
4) Type **<BODY BGCOLOR =#77FFFF>**.
5) Position your cursor in front of the </HTML> tag.
6) Type **</BODY>**.
7) Press **RETURN**.
8) Save your work.
9) Open index.html in your web browser.

Here the <BODY> tag uses the parameter BGCOLOR which itself takes a value in the form of a combination of letters, numbers, or both. The number is a BINHEX, or binary hexagonal digit, and it's in base 16 (Huh?) That just means that instead of using the numbers 0 to 9, you also have A [10], B [11], C [12], D [13], E [14] and F [15]. When you put a pound symbol (#) in front of the number, the HTML reader knows to use base 16 instead of base 10 (regular old numbers). This lets you enter larger numbers using fewer digits (for example, #00 equals 0, #01 equals 1, #0F equals 15, #10 equals 16, #FF equals 255). For the BGCOLOR tag, you're really providing three values of two digits apiece, which tell the browser how much red, green, and blue light to mix together to create the color you want. If you set all of the colors to 0 (#000000), the color is black; if you set all of the colors to 255 (#FFFFFF), the color is white. If you set the numbers to the same value anywhere in between, you get a shade of gray (for example, #AAAAAA will give you a medium-to-dark gray color). By varying the amount of one or more of the values, you can make millions of different color mixes. The number #77FFFF makes a pleasant blue-green shade. This may take you some time to get used to, but you don't have to know exactly how it works to use it. Just try changing the numbers around (remember to use the letters A through F, too!) to see what kinds of colors you can create! Here are the sixteen basic color names understood by all web browsers and their corresponding BINHEX values. You can set a color using either the name or the number. For example, the tag <BODY BGCOLOR = "#FFFFFF"> and the tag <BODY BGCOLOR = WHITE> will both give you a background color of white. The tag <BODY BGCOLOR = RED> and the tag <BODY BGCOLOR = "#FF0000"> with both give you a red background.

| | | | |
|---|---|---|---|
| **Black** | = "#000000" | **Gray** | = "#808080" |
| **Red** | = "#FF0000" | **Maroon** | = "#800000" |
| **Lime** | = "#00FF00" | **Green** | = "#008000" |
| **Blue** | = "#0000FF" | **Navy** | = "#000080" |
| **White** | = "#FFFFFF" | **Silver** | = "#C0C0C0" |
| **Yellow** | = "#FFFF00" | **Olive** | = "#808000" |
| **Fuchsia** | = "#FF00FF" | **Purple** | = "#800080" |
| **Aqua** | = "#00FFFF" | **Teal** | = "#008080" |

WOW! LOOK! THE GREEK EMPIRE IS EMERGING!

THIS IS A LOT MORE FUN THAN KILLING EACH OTHER!

RACE START

The Greek civilization is born; it is the place of origin for most Western philosophy and art.

The first Olympic Games are held. Wars are put on hold while Greeks gather at the city of Olympia to challenge one another to contests of strength and physical prowess.

2200 B.C.

776 B.C.

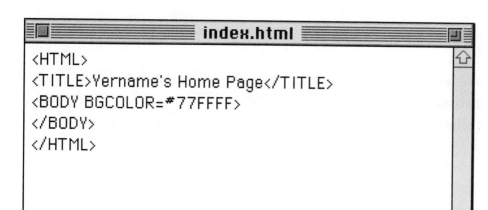

```
<HTML>
<TITLE>Yername's Home Page</TITLE>
<BODY BGCOLOR=#77FFFF>
</BODY>
</HTML>
```

In this tag in our example, the value for red is set to #77, while blue and green are set to their highest values (#FF) . . .

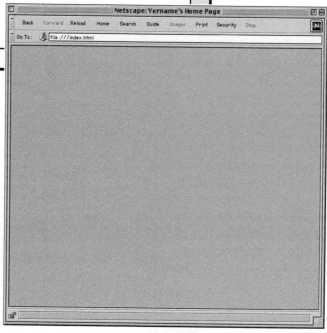

. . . the resulting color is a very nice blue-green (but you'll have to take my word for it!).

The golden age of Greek culture. Sophocles, Aeschylus, Aristophanes, and Euripides were great Greek writers. Their plays are still performed today. Socrates (469-399 B.C.) was a great teacher. The Socratic method—teaching by asking questions and making students think for themselves—follows his style. His most famous question: "What was in that cup?"

Soemup (508–466 B.C.), the great tailor, says on meeting the great playwright, "Euripides? I Soemup."

Hippocrates (460–377 B.C.) was a doctor who believed that medicine should be based on scientific experimentation. Even today, doctors still take the Hippocratic Oath (or a modern version of it), in which they promise to share their knowledge and treat their patients kindly and with dignity.

Plato, Socrates' student, writes *The Republic,* setting down principles that later strongly influence, among others, the founders of the United States.

500 B.C.

# Separators: <HR> and <P> Tags

Blank space is as important as the words and pictures on your web page. Leaving some space lets you group ideas together and makes your page look less cluttered and busy. People who won't read a long paragraph are more likely to read the same information if it's delivered in small doses. You can add separations and blank space to your page using horizontal rules and paragraph tags. (A horizontal rule is a line across the page.) You can also change where the paragraph lines up on the page by using the ALIGN parameter.

Notice that the <HR> tag doesn't have a corresponding </HR> tag. That's because it's a single item that stays in just one position. Most of the other tags can affect several words or pictures, so they need to have one tag to start and another to finish. The <P> tag does have a </P> tag to go with it, but you don't have to use it—your HTML browser knows that the current paragraph ends when the next paragraph begins.

**CONTINUE CREATING YOUR HOMEPAGE**

1) Open index.html in your text editor.
2) Position your cursor after the <BODY> tag and press **RETURN**.
3) Type **<H1>Yername's Home Page</H1>** and press **RETURN**.
4) Type **<HR>** and press **RETURN**.
5) Type **Hi, I'm Yername. Welcome to my homepage!** and press **RETURN**.
6) Type **<P>** and press **RETURN**.
7) Type **Since this is my homepage, I'm going to tell you about some of my favorite stuff.**
8) Save your file and look at it in your web browser.

The rise of the Shang dynasty in China (1766–1122 B.C.). This was an era of great advances in writing, philosophy, and art.

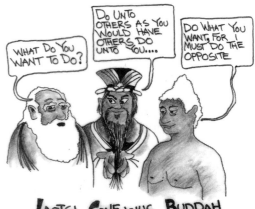

Siddhartha (the Buddha) (560-480 B.C.), founder of Buddhism, is born. Siddhartha was a prince who, when he first saw the suffering of the poor in his country, renounced his throne to become a great teacher and leader.

1766 B.C.                    560 B.C.

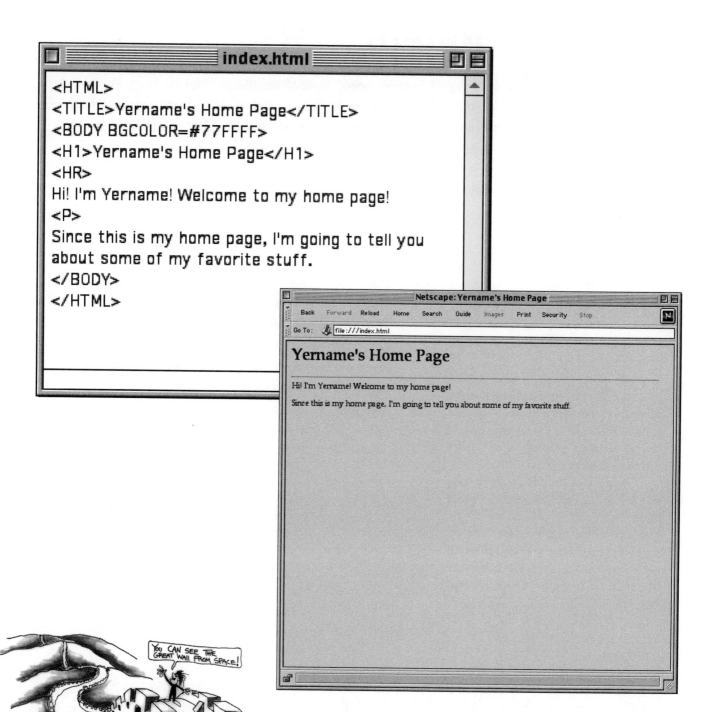

```
<HTML>
<TITLE>Yername's Home Page</TITLE>
<BODY BGCOLOR=#77FFFF>
<H1>Yername's Home Page</H1>
<HR>
Hi! I'm Yername! Welcome to my home page!
<P>
Since this is my home page, I'm going to tell you
about some of my favorite stuff.
</BODY>
</HTML>
```

**index.html**

**Netscape: Yername's Home Page**

Back  Forward  Reload  Home  Search  Guide  Images  Print  Security  Stop

Go To: file:///index.html

## Yername's Home Page

Hi! I'm Yername! Welcome to my home page!

Since this is my home page, I'm going to tell you about some of my favorite stuff.

YOU CAN SEE THE GREAT WALL FROM SPACE!

Laozi (Lao-tzu) (551–479 B.C.), founder of Taoism, active in China. At the age of eighty, disappointed that his countrymen weren't good to one another, he decided to move to Tibet. At the border, the guard asked him to write down his philosophy before he left. In five thousand characters, he wrote the Tao Te Ching, or Way of Life, a simple, straightforward manual for living a good life.

Confucius (551–480 B.C.), great philosopher of ancient China, is active. Confucius is credited with first enunciating the Golden Rule: "Do unto others what you wish to do unto yourself."

The Great Wall of China is completed, isolating China and its ideas from the rest of the world. Chinese art and culture flourish.

500 B.C.

300 B.C.

# Bold ‹B› and Italic ‹I›

Bold and italic text are used to give certain words special emphasis (that is, to make the words stand out from the rest of a paragraph). The most common use of bold text is for headings—in fact, the <H1> through <H6> tags turn the text bold in most browsers. Italics are used for titles of books and movies, and for foreign phrases, but sometimes just for emphasis, too.

Use the <B> tag sparingly! Bold text is like a punch in the eye, so you shouldn't have more than one bold item per page, other than headings.

Italics can be used for a gentler sort of emphasis—they're more like a confidential whisper than a loud shout. Be careful with italics on your web pages, though, because in smaller fonts, italics are hard to read.

One reason to use bold and italic text is that they help you to avoid using underlines and/or all capital letters. Many browsers underline the links on the web pages they display, so using underlines can cause confusion for your users. ALL CAPITALS IS THE VISUAL EQUIVALENT OF YELLING AT SOMEBODY. PEOPLE DON'T LIKE TO BE YELLED AT. IF YOU TYPE TEXT IN ALL CAPITAL LETTERS, PEOPLE WILL GET TIRED OF IT IT AND STOP READING. IT'S ALSO HARDER FOR YOU TO CATCH YOUR TYPOGRAPHICAL ERRORS. (Did you see the mistake? I said "it" twice in the third sentence.)

Using a mixture of upper- and lowercase letters makes it easier to read words all at once, because we recognize the shape of the word, with all of its ups and downs. Words in all capital letters look rectangular.

**LET'S ADD BOLD AND ITALIC TEXT TO YOUR PAGE**

1) Open index.html in your text editor.

2) Change the first paragraph to **<B>Hi, I'm Yername</B>. Welcome to my homepage!**

3) Change the second paragraph to **Since this is <I>my</I> homepage, I'm going to tell you about some of my favorite stuff.**

4) Save your file and look at it in your web browser.

The Etruscan civilization grows strong. The predecessors to the Romans, the Etruscans had many wonderful artisans, primarily sculptors and potters.

Rome is founded. The Romans were a bold italic people.

800 B.C.

753 B.C.

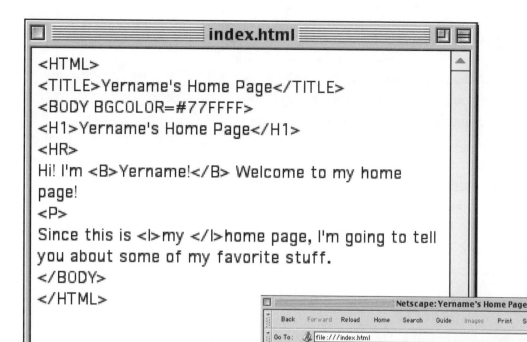

```
<HTML>
<TITLE>Yername's Home Page</TITLE>
<BODY BGCOLOR=#77FFFF>
<H1>Yername's Home Page</H1>
<HR>
Hi! I'm <B>Yername!</B> Welcome to my home
page!
<P>
Since this is <I>my </I>home page, I'm going to tell
you about some of my favorite stuff.
</BODY>
</HTML>
```

Jesus, son of Mary and Joseph, is born in Bethlehem. Western calendars, called Gregorian calendars, use His birthdate as their starting point, with all dates prior to His birth referred to as "B.C." for "before Christ" and all dates after His birth referred to as "A.D.," or "anno domini," Latin for "Year of Our Lord."

The language of the Romans was Latin. All great works in western literature were written (or translated) in Latin for 1,500 years after the fall of the Roman empire in A.D. 476. Latin is still used today in law, medicine, and science. Until very recently, the Catholic mass was celebrated in Latin. Latin enabled people from different countries and backgrounds to communicate in a common language, wherever they went.

# Ordered Lists <OL>

People are always making lists: they make shopping lists, lists of instructions, lists of ingredients, and lists of party guests, to name a few. When scientists and researchers began using the Internet to share information about experiments, they needed a way to list the steps in the order that would ensure an experiment's success. When they were figuring out the correct process, they would often have to add steps or move them around. Rather than renumber the list every time they made a change, HTML was designed so that they could just list the steps in order, and have the web browser automatically number them when the page was displayed. It's pretty convenient. You start a numbered list with the tag <OL>, for Ordered List, and mark each piece of information with the tag <LI>, for List Item. You can also add a <LH> (list header), if you want a special heading for the list. Let's list your favorite foods.

-----------------------------------------------------------------------------------------------

### TO CREATE AN ORDERED LIST

1) Open index.html in your text editor.

2) Position your cursor after the word "stuff" and press **RETURN**.

3) Type **<P>** and press **RETURN**.

4 Type **<OL>** and press **RETURN**.

5) Type **<LH>My Favorite Foods</LH>** and press **RETURN**.

6) Type **<LI>Asparagus** and press **RETURN**.

7) Finish the list as follows:

    **<LI>Kale**

    **<LI>Sauerkraut**

    **<LI>Brussels Sprouts**

    **<LI>Cauliflower**

8) Type **</OL>**.

9) Open the file in your web browser and take a look.

*If these vegetables aren't technically your favorite foods, feel free to substitute other vegetables, or completely different food products. Just be sure to eat five fruits or vegetables per day.*

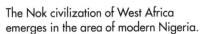

The Nok civilization of West Africa emerges in the area of modern Nigeria.

The Nok begin mining and smelting iron. Everyone looks accusingly at one another, but decide that they who smelt it dealt it.

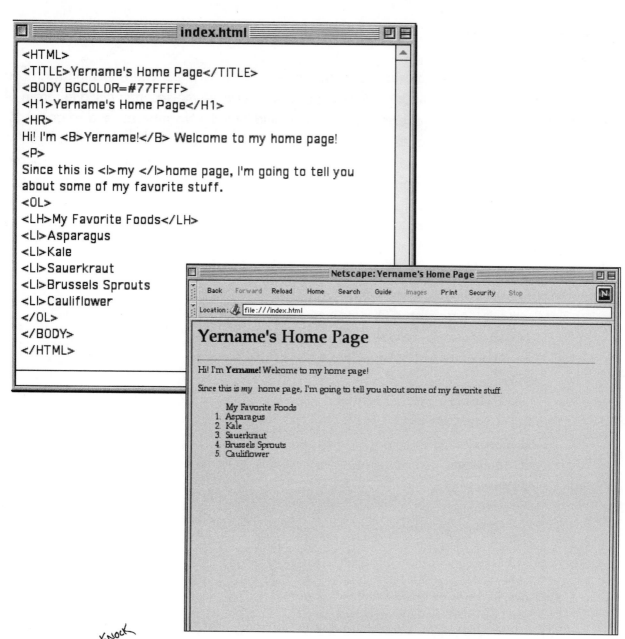

```
<HTML>
<TITLE>Yername's Home Page</TITLE>
<BODY BGCOLOR=#77FFFF>
<H1>Yername's Home Page</H1>
<HR>
Hi! I'm <B>Yername!</B> Welcome to my home page!
<P>
Since this is <I>my </I>home page, I'm going to tell you
about some of my favorite stuff.
<OL>
<LH>My Favorite Foods</LH>
<LI>Asparagus
<LI>Kale
<LI>Sauerkraut
<LI>Brussels Sprouts
<LI>Cauliflower
</OL>
</BODY>
</HTML>
```

**Yername's Home Page**

Hi! I'm **Yername!** Welcome to my home page!

Since this is *my* home page, I'm going to tell you about some of my favorite stuff.

My Favorite Foods
1. Asparagus
2. Kale
3. Sauerkraut
4. Brussels Sprouts
5. Cauliflower

Invention of the doorbell. This was vital to the sanity of the Nok people who were weary of the old joke, "Did you hear a Nok at the door?"

The Nok people created beautiful statues in terra-cotta (Italian for "baked earth"). Theirs is some of the earliest statuary to be found in Africa south of the Sahara Desert. They created life-like statues of important people as well as religious artifacts. To this day, Nigeria benefits from the rich artistic and cultural heritage of the Nok.

# Unordered Lists <UL>

Ordered lists are used to show the steps in a process (do this first, this second, this third, and so on) or to say one item is more important than another (my favorite movies: number one, Brain of the Smart Guy; number two, Chipper, the Dog Who Could Play the Harmonica; and so on). A lot of lists don't have a special order to them. A shopping list, for example, lists everything you're supposed to buy, so there's no need to list it in any order. A list like this is called an "unordered list." It works just the same as the ordered list you've already created, but instead of numbers, it puts round marks called *bullets* at the start of each new item.

---

**TO CREATE AN UNORDERED LIST**

1) Open index.html in your text editor.

2) Position your cursor after </OL> and press **RETURN**.

3) Type **<UL>** and press **RETURN**.

4) Type **<LH>Some of My Favorite People</LH>** and press **RETURN**.

5) Type **<LI>Lumpy** and press **RETURN**.

6) Fill out the list as follows:*

   **<LI>Sneezy**

   **<LI>Squinky**

   **<LI>Wacky**

7) Type **</UL>**.

8) Open the file in your web browser and take a look.

*Substitute a list of your friends, if you like, or I can introduce you to Lumpy, Sneezy, Squinky, and Wacky.

The Maya civilization of Mexico begins to record its history, on pottery, stellae (stone pillars), bones, and wall murals.

The Mayans create an extensive empire in South America, with large cities, a sophisticated system of roads, mining, and advanced agriculture.

50 A.D.

300 A.D.

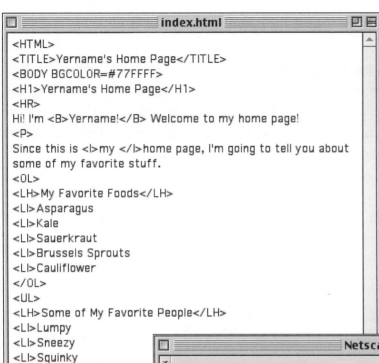

```
<HTML>
<TITLE>Yername's Home Page</TITLE>
<BODY BGCOLOR=#77FFFF>
<H1>Yername's Home Page</H1>
<HR>
Hi! I'm <B>Yername!</B> Welcome to my home page!
<P>
Since this is <I>my </I>home page, I'm going to tell you about
some of my favorite stuff.
<OL>
<LH>My Favorite Foods</LH>
<LI>Asparagus
<LI>Kale
<LI>Sauerkraut
<LI>Brussels Sprouts
<LI>Cauliflower
</OL>
<UL>
<LH>Some of My Favorite People</LH>
<LI>Lumpy
<LI>Sneezy
<LI>Squinky
<LI>Wacky
</UL>
</BODY>
</HTML>
```

"Favorite Foods" is an ordered list, with numbers. "Favorite People" is an unordered list, with bullets.

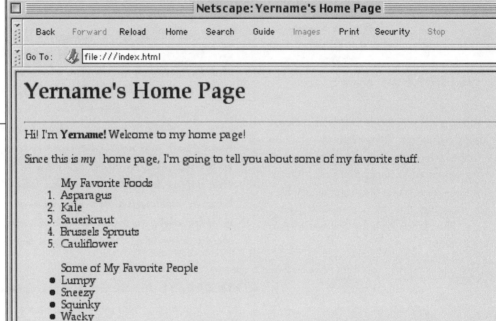

The Mayan empire reaches its peak, with extensive achievements in mathematics and astronomy, art and culture. The Maya were also a proud and warlike people whose rituals included the drawing of blood, not only from enemies, but also from the king and high-ranking nobles.

Aztec King Chaan-muan commissions the mural at Bonampak. The painting fills three rooms, and is not merely beautiful, but 1,200 years later it gives us a window into courtly life in ancient Mexico.

A.D. 792                               A.D. 909

# Linking to Another Page Using <A HREF>

The <A HREF> tag is the tag that makes the Web a web. Let's say that instead of using computers, we're using juice-can-and-string telephones.* You and I could have a phone, and you and Squinky could have another phone. I send a message to you, and you pass it on to Squinky. He can reply to you, and you relay his message to me. Better still, I can add a third phone, and talk to Squinky directly. Now, if Lumpy wants to get into the conversation, he can share a phone with any one of us, or he can make it easier and add three more phones, so that he can talk to each of us directly (that's six phones, total!). The string running back and forth between our houses is going to form the beginnings of a network, like a spider's web. Now (to make a long story short), add everybody in the world to your juice-can-phone network: the Earth looks like a fly wrapped up for eating. Then substitute computers for juice cans. That's why it's called the World Wide Web.

## <A HREF=> Tag

This tag lets you make words or pictures into hypertext links. Put <A HREF= "http://www.anyURL.com"> in front of the words or pictures that will indicate the link, and place the </A> afterward, to show that the link is complete. (There are other kinds of links that we'll learn about later.)

*Once again, I'm showing my age! To make a juice-can telephone, you'll need two six-ounce cans from orange-juice concentrate, two buttons, and some thread. Have your parents help you poke a hole in the bottom of each can. Stick the thread through the bottom of one can, then tie it to a button to keep it in place. Reel off about fifty feet of thread, cut it, then stick it though the bottom of the second can, and tie it to the other button. Pull the thread taunt (but not so tight that it breaks!), and start talking: one person speaks into his or her can while the other holds it up to an ear. The thread will vibrate, carrying the sound waves, and the receiver will be able to hear what is said at the far end. This was a big deal thirty years ago.*

### TO CREATE A LINK TO ANOTHER WEB PAGE

1) Open index.html in your text editor.
2) Position your cursor after Wacky (or the last name on the unordered list) and press **RETURN**.
3) Type **<LI><A HREF= "http://www.draw3d.com">Mark</A>**.
4) Save your work, and open it in your web browser.
5) Click the link you've just created to visit the Official Imagination Station web site!

The Visigoths sack Rome, taking gold, jewels, arms, and food. The Roman empire continues its rapid decline, and finally falls in A.D. 476.

St. Patrick (389-461) becomes Bishop of Ireland. He wins toleration for Christians from the non-Christian population, and converts many nobles.

Constant warfare, burning, looting, and intentional destruction destroy virtually all libraries in continental Europe.

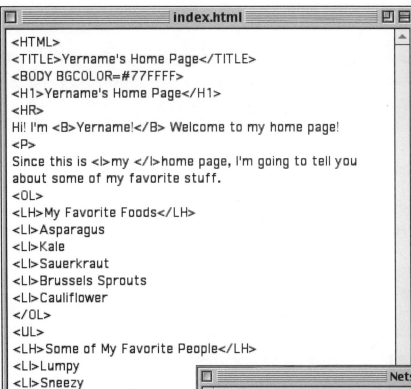

```
<HTML>
<TITLE>Yername's Home Page</TITLE>
<BODY BGCOLOR=#77FFFF>
<H1>Yername's Home Page</H1>
<HR>
Hi! I'm <B>Yername!</B> Welcome to my home page!
<P>
Since this is <I>my </I>home page, I'm going to tell you
about some of my favorite stuff.
<OL>
<LH>My Favorite Foods</LH>
<LI>Asparagus
<LI>Kale
<LI>Sauerkraut
<LI>Brussels Sprouts
<LI>Cauliflower
</OL>
<UL>
<LH>Some of My Favorite People</LH>
<LI>Lumpy
<LI>Sneezy
<LI>Squinky
<LI>Wacky
<LI><A HREF="http://www.dr
</UL>
</BODY>
</HTML>
```

## Nesting

When we added Mark to your unordered list, we also added a link. This placing of one item within another is called nesting. You can use several tags on the same words, depending on the effect you want, but be sure you add the closing tags in reverse order. If you make a link appear in bold, for instance, you would type
**<B><A HREF="link"></A></B>**,
not
<B><A HREF = "link"></B></A>.

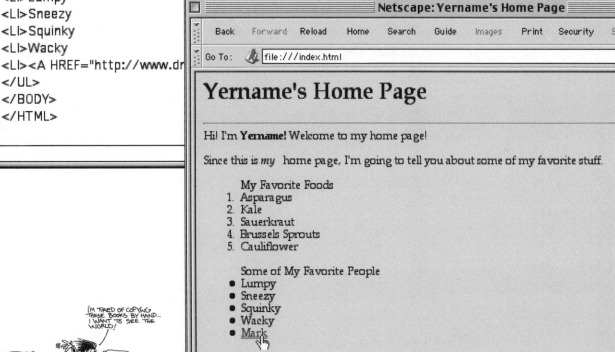

Irish monks, isolated from the rest of Europe's upheaval, have been peacefully copying books for their monastery libraries. As they begin to travel through Europe, they redistribute the Latin literature that they have preserved.

Muhammad, while in a cave on Mount Hira outside Mecca, has a vision in which he is called on to preach the message of God. He becomes the founder of Islam.

European Christians undertake the First Crusade, on which they fight Moslems for possession of the Holy Land. There is much needless bloodshed, but this and ensuing crusades also result in the mixing of cultures and the exchange of ideas between East and West.

# The ‹ADDRESS› Tag

The last tag we'll look at for your homepage is the Address tag. By convention, most web authors put information at the bottom of their pages that tells people how they can write back and say what they think of the site. You don't have to do this, but if your parents say it's okay, putting your e-mail address on the bottom of your page is a way to make your web site interactive, instead of a one-way information dump.

## TO CREATE AN ADDRESS WITH A RETURN-MAIL LINK

1) Open index.html in your text editor.
2) Position your cursor in front of the </BODY> tag.
3) Type **<HR>** and press **RETURN**.
4) Type **<ADDRESS>** and press **RETURN**.
5) Type **This page was created and is maintained by <A HREF="mailto:yername@yerISP.net">Yername Magoo</A>** and press **RETURN**. (Replace "yername@yerISP.net" with your own e-mail address.)
6) Type **<P>** and press **RETURN**.
7) Type **Last updated**, followed by today's date, then press **RETURN**.
8) Type **</ADDRESS>** and press **RETURN**.
9) Save your work, and open the page in your web browser to take a look.

Vikings land in Nova Scotia, four hundred years before Columbus sets foot on Hispaniola. They established a colony, but it didn't survive more than a couple of years.

Genghis Khan, leader of the Mongols, begins his campaign to conquer Europe and Asia. Had he not died with his armies ready to attack Western Europe, he might have succeeded.

A.D. 1100          A.D. 1187

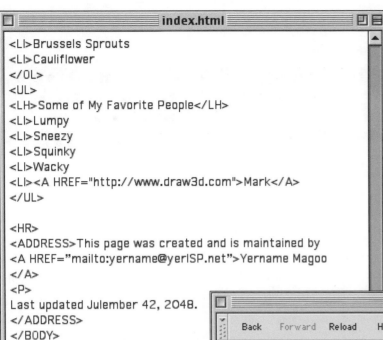

```
<LI>Brussels Sprouts
<LI>Cauliflower
</OL>
<UL>
<LH>Some of My Favorite People</LH>
<LI>Lumpy
<LI>Sneezy
<LI>Squinky
<LI>Wacky
<LI><A HREF="http://www.draw3d.com">Mark</A>
</UL>

<HR>
<ADDRESS>This page was created and is maintained by
<A HREF="mailto:yername@yerISP.net">Yername Magoo
</A>
<P>
Last updated Julember 42, 2048.
</ADDRESS>
</BODY>
</HTML>
```

Here's just the bottom of the file, where you've added in the <ADDRESS> information.

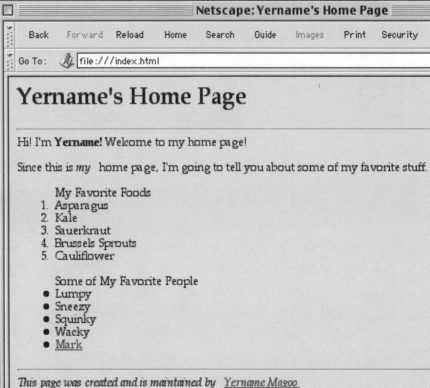

# Yername's Home Page

Hi! I'm **Yername!** Welcome to my home page!

Since this is *my* home page, I'm going to tell you about some of my favorite stuff.

My Favorite Foods
1. Asparagus
2. Kale
3. Sauerkraut
4. Brussels Sprouts
5. Cauliflower

Some of My Favorite People
- Lumpy
- Sneezy
- Squinky
- Wacky
- Mark

*This page was created and is maintained by* Yername Magoo

*Last updated Julember 42, 2048.*

Rats! Europe is devastated by the Black Death, otherwise known as the Bubonic Plague. The dread disease killed one in three people. It wasn't the rats, but the fleas on the rats that spread the disease. Gross!

Zhu Yuanzhang is the first emperor of China in the Ming dynasty. The Mongols are overthrown, and China enters a great period of growth and innovation in all of the arts, particularly pottery.

# Cool Sites!

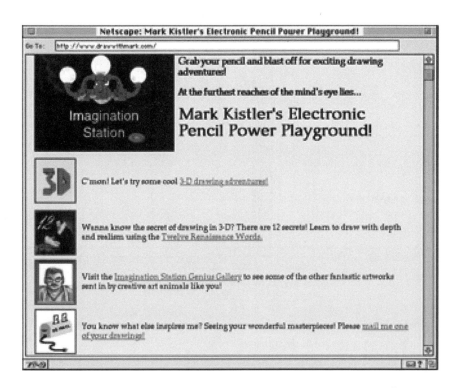

## Mark Kistler's Imagination Station
### www.draw3d.com

*Mark Kistler's Imagination Station* is where you'll find 3-D drawing lessons, games, an art gallery filled with pictures drawn by art animals like you, and links to other cool Web sites and super art heroes! You'll also find the example files we used for the projects in this book.

The Internet is a dynamic, growing, changing, expanding, explosive universe where nothing stays still for very long. The URLs you find in this book may change by the time you read this. Don't worry, though: you'll find the current URLs for all of the sites mentioned in this book in the Web Wizards section of *Mark Kistler's Imagination Station.*

# Seven Wonders of the Ancient World

Most people have heard that there are Seven Wonders of the World, but can you name them? Who built these amazing things, and for whom did they build them?

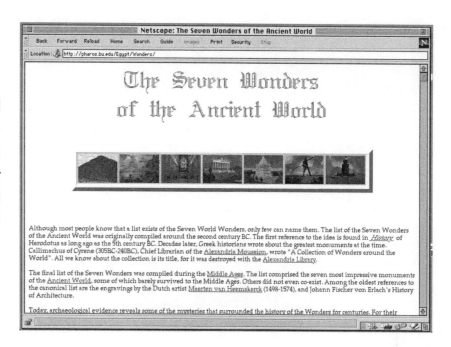

## The Seven Wonders of the Ancient World

Although most people know that a list exists of the Seven World Wonders, only few can name them. The list of the Seven Wonders of the Ancient World was originally compiled around the second century BC. The first reference to the idea is found in *History* of Herodotus as long ago as the 5th century BC. Decades later, Greek historians wrote about the greatest monuments at the time. Callimachus of Cyrene (305BC-240BC), Chief Librarian of the Alexandria Mouseion, wrote "A Collection of Wonders around the World". All we know about the collection is its title, for it was destroyed with the Alexandria Library.

The final list of the Seven Wonders was compiled during the Middle Ages. The list comprised the seven most impressive monuments of the Ancient World, some of which barely survived to the Middle Ages. Others did not even co-exist. Among the oldest references to the canonical list are the engravings by the Dutch artist Maerten van Heemskerck (1498-1574), and Johann Fischer von Erlach's History of Architecture.

Today, archaeological evidence reveals some of the mysteries that surrounded the history of the Wonders for centuries. For their

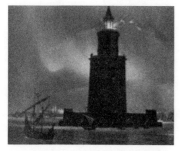

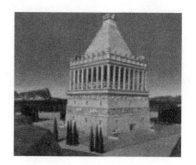

What if you were going to build a monument to one of your heroes (Mom or Dad, a teacher, your cat . . .)? What would you build? Would it be a tall building? A statue? A garden? A giant cupcake? Why don't you create a web site all about that amazing genius hero, YOU?

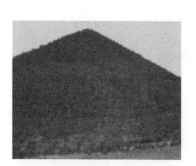

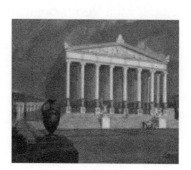

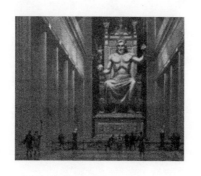

# Cool Sites Continued

The Seven Wonders site also lists other ancient wonders, like Stonehenge and the Great Wall of China, modern ones like the Empire State Building and the Channel Tunnel, and natural wonders such as Mount Fuji and Angel Falls.

**www.pharos.edu/Egypt/Wonders/**

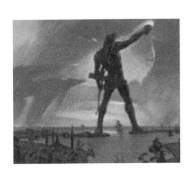

## The Louvre

The Louvre, in France, is one of the world's great art museums. Its web site has images of some of the world's best-known artworks, including the Venus de Milo and the Mona Lisa. You'll also find pictures of artworks from ancient Rome, Greece, China, and Egypt.

**mistral.culture.fr/ louvre/louvrea.htm**

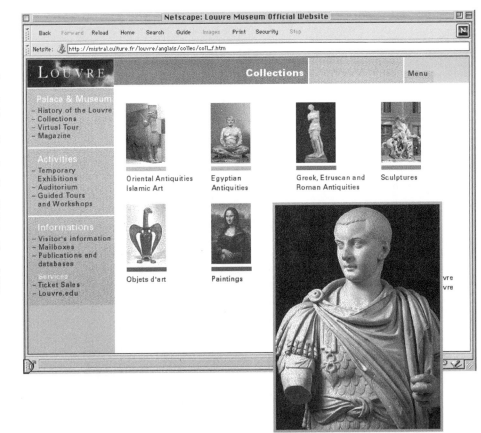

## Tour Egypt

Like ancient Egypt? You can go right to the source. The Tour Egypt web site has hundreds of pictures and descriptions of monuments and attractions from all over Egypt.

**http://touregypt.net**

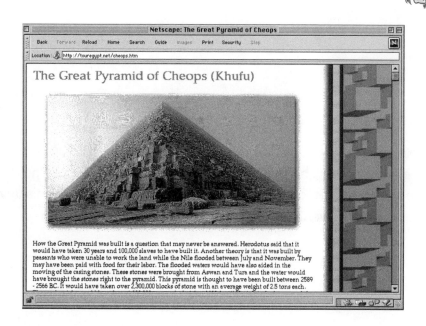

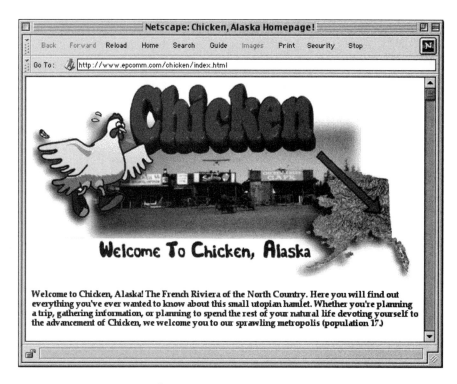

## Chicken, Alaska

Television genius Douglas DeVore spent many of his summers in the tiny town of Chicken, Alaska, working as a miner, tour guide, and at other odd jobs. He created a web site dedicated to this tiny burg of only seventeen residents! **www.draw3d.com**

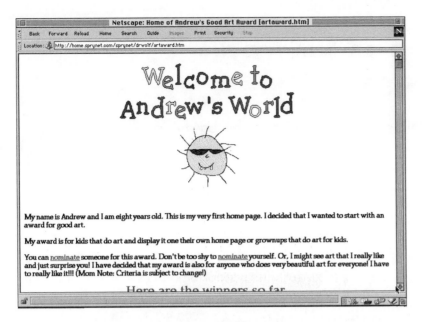

*Netscape: Home of Andrew's Good Art Award [artaward.htm]*

Back  Forward  Reload  Home  Search  Guide  Images  Print  Security  Stop

Location: http://home.sprynet.com/sprynet/drwolf/artaward.htm

# Welcome to Andrew's World

My name is Andrew and I am eight years old. This is my very first home page. I decided that I wanted to start with an award for good art.

My award is for kids that do art and display it one their own home page or grownups that do art for kids.

You can nominate someone for this award. Don't be too shy to nominate yourself. Or, I might see art that I really like and just surprise you! I have decided that my award is also for anyone who does very beautiful art for everyone! I have to really like it!!! (Mom Note: Criteria is subject to change!)

Here are the winners so far.

## *Andrew's World*

Andrew and his mom created Andrew's World, home of Andrew's Good Art Award. You'll see awards from him proudly displayed on some of the best art sites on the Internet. Andrew also has his own art and photo galleries, so you can see some of the art that he himself likes. Pretty amazing for someone who started his site at the ripe old age of six!

**home.sprynet.com/sprynet/drwolf/artaward.htm**

---

# What Have You Done?

Hey! You've created your own homepage! You've learned how to make lists with numbers and bullets. That's a great start! It's so good, actually, that you can't keep this to yourself any longer! The time has come to share your new skills with your classmates and create a cool web page for your classroom!

# 3. Creating a Classroom Homepage

Be cool to your school! In this lesson, we're going to put together a page that you might use for your classroom. You can store all kinds of useful information on a class web site: homework assignments, spelling words, math problems, books, links to research sites. You might also want to include a list of important upcoming events, such as the date of the next <SHAMELESS PLUG>Mark Kistler Drawing in 3-D assembly!</SHAMELESS PLUG>.

For this chapter, we're going to build on the HTML skills you've already learned. Instead of a flat color background, we'll use a picture of the school logo. We'll link to pages that use tables to display a calendar and homework listing in a way that makes them easy to skim over to find the information we want.

## Shame on You!

**<SHAMELESS PLUG>**
There's no such a thing as a <SHAMELESS PLUG> tag in HTML (though it might be a good idea). One nice thing about Hyper Text Markup Language is that the inventors have planned it out so that when a new tag is defined, you can drop it right into your Web page. If a browser is old and doesn't recognize the new tag, that's okay—it just ignores it (nothing shows on screen). This way, everyone on the Internet can continue to browse for the information they need without having to get every new version of the browser every time some little thing changes. But even so, you'll still want to update your browser software regularly to take advantage of the cooler new features as they come available.

**index.html** If you name a file index.html, the Internet server that makes your page available on the Internet knows that that file is the first page that people should see when they come to your web page directory.

### TO START YOUR CLASSROOM HOMEPAGE

1) This time, create the basic components of your classroom homepage on your own. Try to make a page that looks similar to the example on page 45. (The complete HTML file is shown next to it. No fair peeking.*)

2) Save the page as index.html.

*❋ Well, you can peek a bit—if you must. This isn't your classroom, this isn't math period, and this isn't a test. But I'll bet you'll be surprised at how much you can do without looking at the answer!*

THE RENAISSANCE WAS LIKE OPENNING A VAST TREASURE CHEST OF MUSIC, SCIENCE, ART AND EXPLORATION OF THE WORLD!

The Renaissance begins and spreads through Europe. Renaissance is French for *rebirth*. In the Renaissance, classical knowledge that had been hidden or lost to Europe was rediscovered. Great advances in science and art were achieved during this era.

Renaissance results in the Regurgitance (French for *reburp*) after feeding.

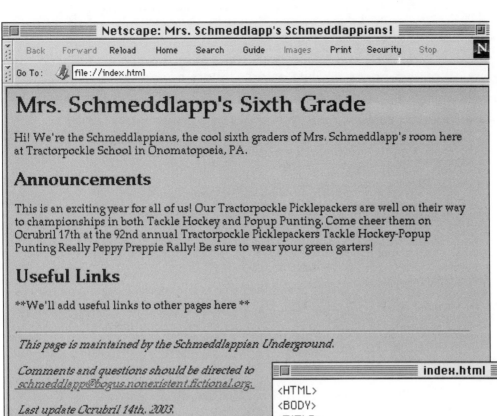

Back | Forward | Reload | Home | Search | Guide | Images | Print | Security | Stop

Go To: file://index.html

# Mrs. Schmeddlapp's Sixth Grade

Hi! We're the Schmeddlappians, the cool sixth graders of Mrs. Schmeddlapp's room here at Tractorpockle School in Onomatopoeia, PA.

## Announcements

This is an exciting year for all of us! Our Tractorpockle Picklepackers are well on their way to championships in both Tackle Hockey and Popup Punting. Come cheer them on Ocrubril 17th at the 92nd annual Tractorpockle Picklepackers Tackle Hockey-Popup Punting Really Peppy Preppie Rally! Be sure to wear your green garters!

## Useful Links

**We'll add useful links to other pages here **

---

*This page is maintained by the Schmeddlappian Underground.*

*Comments and questions should be directed to schmeddlapp@bogus.nonexistent.fictional.org.*

*Last update Ocrubril 14th, 2003.*

You are offline. Choose "Go Online..." to connect.

A "Renaissance person" is a well-rounded individual who excels in many areas, physically, intellectually, and artistically. One example of a Renaissance man who actually lived in the Renaissance is Sir Walter Raleigh. He was an explorer who helped to colonize North America, a poet and patron of the arts, and a favorite of Queen Elizabeth I. While imprisoned for political reasons, he filled his time writing *History of the World.*

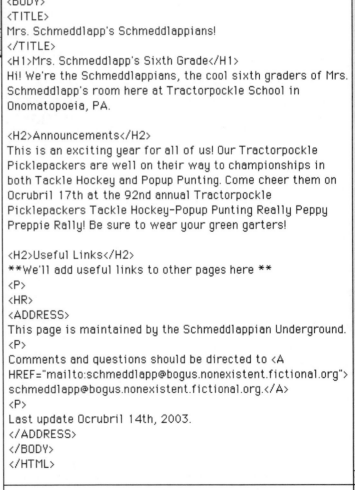

index.html

```
<HTML>
<BODY>
<TITLE>
Mrs. Schmeddlapp's Schmeddlappians!
</TITLE>
<H1>Mrs. Schmeddlapp's Sixth Grade</H1>
Hi! We're the Schmeddlappians, the cool sixth graders of Mrs.
Schmeddlapp's room here at Tractorpockle School in
Onomatopoeia, PA.

<H2>Announcements</H2>
This is an exciting year for all of us! Our Tractorpockle
Picklepackers are well on their way to championships in
both Tackle Hockey and Popup Punting. Come cheer them on
Ocrubril 17th at the 92nd annual Tractorpockle
Picklepackers Tackle Hockey-Popup Punting Really Peppy
Preppie Rally! Be sure to wear your green garters!

<H2>Useful Links</H2>
**We'll add useful links to other pages here **
<P>
<HR>
<ADDRESS>
This page is maintained by the Schmeddlappian Underground.
<P>
Comments and questions should be directed to <A
HREF="mailto:schmeddlapp@bogus.nonexistent.fictional.org">
schmeddlapp@bogus.nonexistent.fictional.org.</A>
<P>
Last update Ocrubril 14th, 2003.
</ADDRESS>
</BODY>
</HTML>
```

# Using a Background Image

By default, the background of web pages is white or gray. That's not an accident—it's easiest to read information when it's set against a neutral background. But it also gets boring after a while. You can add interest to your web pages by using a background image. Keep in mind, though, that people come to your web site to get information, so you have to be sure that whatever background you put up, the page is easy to read.

**Classy!**

### Tiling

If your background image doesn't fill up the entire background, your Internet browser repeats the image until it fills the entire window. This is known as tiling. Since everyone sets the size of their browser window differently, tiling is the only way you can be sure that the entire background will be filled.

When you create your background image, it's best to keep the edges of the image all one color, so that it blends smoothly as it's tiled. You may also want to overlap images so that it repeats without an obvious "seam" between repetitions. For example, look at pickles.gif to see how I made some of the pickles start at the bottom and finish on the top. When it's tiled, the pickles overlap for a nice effect.

### TO ADD A BACKGROUND IMAGE AND THE SCHOOL LOGO

1)  Scan or draw (using a painting program) your background image and save it as a .GIF or JPEG file. You can find the images we're using at www.draw3d.com.
2)  Copy the image to the same directory as your HTML page (index.html).
3)  Open index.html in your text editor.
4)  Change the BODY tag to include the BACKGROUND parameter as follows: **<BODY BACKGROUND="pickles.gif">**.
5)  Position your cursor after the </TITLE> tag and press **RETURN**.
6)  Type the following command, which will display and center the school logo:
    **<P ALIGN=CENTER><IMG SRC="school.gif">**.
7)  Save your work and open the file in an Internet browser.

Portugal was the first country to show signs of Renaissance. Francesco Petrarca, known in England as Petrarch, is the Portuguese poet and historian who popularized the model of great love poetry, the sonnet, to which Shakespeare applied himself three centuries later.

Prince Henry the Navigator (1394–1460) sponsors Portuguese voyages of exploration along the Atlantic coast of Africa in the early fifteenth century. Prince Henry the Pilot did the steering, and Prince Henry the Swabbie kept the decks sparkling.

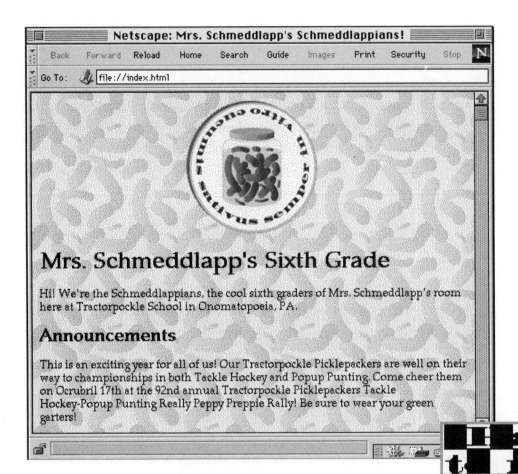

Look at the pickles in the jar, compared to the pickles in the background. I used the same picture for both, but I changed the contrast, (the difference between the dark and light parts of the picture) for the picture in the background.

Usually, you want a lot of contrast in your picture to make details show clearly. In this case, however, I want very little contrast, so that the words are displayed on a neutral background. Notice how the text on the black-and-white boxes is hard to read, while the words on the gray boxes are easy to read.

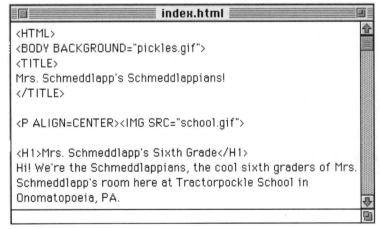

Two simple lines that add two simple graphics to the page resulted in a much more interesting front page to the web site!

```
<HTML>
<BODY BACKGROUND="pickles.gif">
<TITLE>
Mrs. Schmeddlapp's Schmeddlappians!
</TITLE>

<P ALIGN=CENTER><IMG SRC="school.gif">

<H1>Mrs. Schmeddlapp's Sixth Grade</H1>
Hi! We're the Schmeddlappians, the cool sixth graders of Mrs.
Schmeddlapp's room here at Tractorpockle School in
Onomatopoeia, PA.
```

Donato di Niccolo di Bette Bardi, called Donatello (1386–1466), began sculpting in the classical style of the Greeks and Romans, producing statues of great realism and beauty. His sculptures are of real people who seem to have personalities, rather than symbols and stereotypes. A Ninja Turtle was named after him.

# Adding a Table

Tables are used when you have pieces of information that people should read left to right across columns, rather than top to bottom. Tables arrange information in a way that makes it easy for your users to skim through your site and find what they want. Tables take a couple of pages to explain, but once you get the hang of them, you'll use them all the time.

We'll create a new web page with a table that shows a list of coming events for Tractorpockle School.

## Recycle, Reduce, Reuse!

Recycling can not only save the planet, but it can also reduce the time you spend writing computer code. Once you've created a web page that looks the way you like it, you can copy and paste, or choose Save As, to reuse the HTML code you've already created.

A computer is a tool, not a brain. It's more like a hammer than a human. It can't laugh or tie a shoe or ride a bike or do any of a thousand things you do every day. But computers are very good at helping us do some things: they can calculate, communicate, and imitate, and are not distracted by things happening around them.

Creating something on the computer is fun and interesting—you can draw pictures, write stories, and create web pages. But rewriting the same things over and over gets boring. Let your computer do all of your repetitive and mindless tasks, so that you're free to do creative, exciting, stimulating, groundbreaking, genius work!

### TO CREATE A NEW PAGE WITH A TABLE

1) Open index.html in your text editor.
2) From the File menu, choose Save as . . .
3) Name the file **calendar.html**.
4) Change the title information to
   **<TITLE>Calendar of Events</TITLE>**
5) Change the <H1> heading to
   **Tractorpockle School Calendar of Events**.
6) Delete everything between </H1> and <HR>
   (but keep the address information, which is
   still the same).
7) Type **<TABLE>** and press **RETURN**.
8) Type **</TABLE>**.

Now, let's move on to filling out the table.

Johannes Gutenberg (1398–1468) invents the movable-type printing press.

Movable-type presses had been tried in China and Korea 400 years earlier, but the complex alphabet (over 10,000 different characters, called ideograms) made the process impractical.

1440s

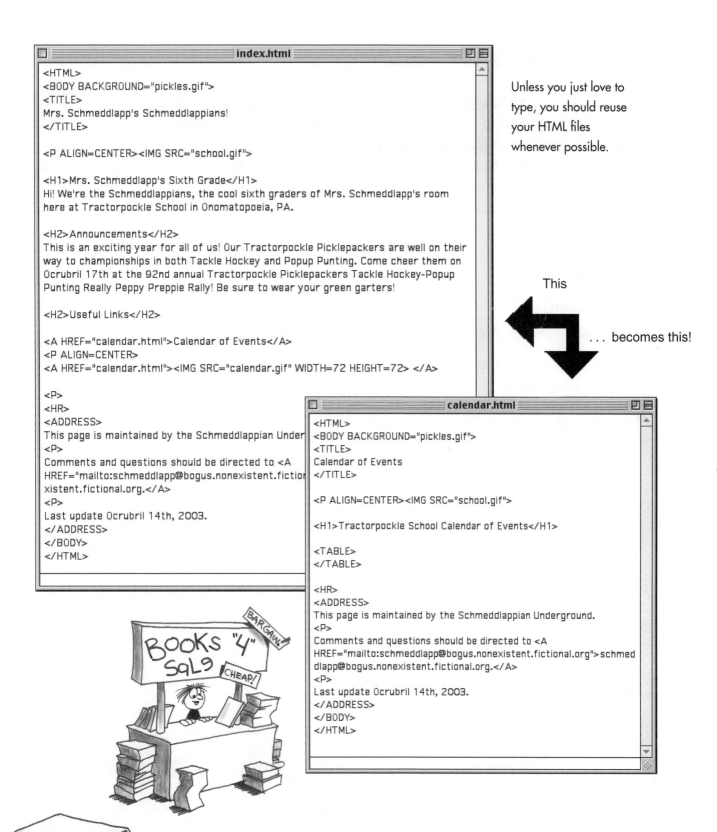

**index.html**

```
<HTML>
<BODY BACKGROUND="pickles.gif">
<TITLE>
Mrs. Schmeddlapp's Schmeddlappians!
</TITLE>

<P ALIGN=CENTER><IMG SRC="school.gif">

<H1>Mrs. Schmeddlapp's Sixth Grade</H1>
Hi! We're the Schmeddlappians, the cool sixth graders of Mrs. Schmeddlapp's room
here at Tractorpockle School in Onomatopoeia, PA.

<H2>Announcements</H2>
This is an exciting year for all of us! Our Tractorpockle Picklepackers are well on their
way to championships in both Tackle Hockey and Popup Punting. Come cheer them on
Ocrubril 17th at the 92nd annual Tractorpockle Picklepackers Tackle Hockey-Popup
Punting Really Peppy Preppie Rally! Be sure to wear your green garters!

<H2>Useful Links</H2>

<A HREF="calendar.html">Calendar of Events</A>
<P ALIGN=CENTER>
<A HREF="calendar.html"><IMG SRC="calendar.gif" WIDTH=72 HEIGHT=72> </A>

<P>
<HR>
<ADDRESS>
This page is maintained by the Schmeddlappian Under
<P>
Comments and questions should be directed to <A
HREF="mailto:schmeddlapp@bogus.nonexistent.fictio
xistent.fictional.org.</A>
<P>
Last update Ocrubril 14th, 2003.
</ADDRESS>
</BODY>
</HTML>
```

**calendar.html**

```
<HTML>
<BODY BACKGROUND="pickles.gif">
<TITLE>
Calendar of Events
</TITLE>

<P ALIGN=CENTER><IMG SRC="school.gif">

<H1>Tractorpockle School Calendar of Events</H1>

<TABLE>
</TABLE>

<HR>
<ADDRESS>
This page is maintained by the Schmeddlappian Underground.
<P>
Comments and questions should be directed to <A
HREF="mailto:schmeddlapp@bogus.nonexistent.fictional.org">schmed
dlapp@bogus.nonexistent.fictional.org.</A>
<P>
Last update Ocrubril 14th, 2003.
</ADDRESS>
</BODY>
</HTML>
```

Unless you just love to type, you should reuse your HTML files whenever possible.

This

... becomes this!

Gutenberg prints the Christian Bible on vellum. Nearly fifty of his Bibles still remain. He used six presses on the Bibles, printing only twenty to forty pages per day.

The printing press changed the world by making books cheap enough that common people could afford to buy them and learn to read. Before the press, only five in 100 Europeans could read.

BOOKS "4" SaL9 BARGAIN CHEAP! BIBLE

# Creating Table Rows and Headings

When you type your table into HTML, it looks nothing at all like the final product will in your web browser. Tables use a whole bunch of different tags to show where each part of the table begins and ends. We'll start by creating the table headings.

When I create tables, I usually type the starting and ending tags for each row and cell, then I click between the tags and enter the information. You don't have to do it this way—you can type the tags in order if you like, but by doing each set of tags together I know I've created a complete set each time.

## Table Terminology!

It helps to know what the different parts of the table are called.

When you look at a table, it looks something like a brick wall. The "bricks" are called cells. Each cell is used to store one piece of information, like a date, a name, an event, or whatever unit of data you're using.

Cells arranged in a stack (up and down) are called a column. Cells arranged left to right are called a row. Usually, the first row contains bold column headings.

The line between the cells is called a border. You don't have to use borders, but sometimes they help you to read across the table by separating information.

## TO CREATE TABLE ROWS AND HEADINGS

1) Open calendar.html, if it's not open already.
2) To add a border to the table, change the <TABLE> tag to **<TABLE BORDER=1>**.
3) Position your cursor after the <TABLE> tag and press **RETURN**.
4) Type **<TR>**, press **RETURN**, then type **</TR>** (these tags create a table row).
5) Position your cursor after the <TR> tag and press **RETURN**.
6) Type **<TH>**, press **RETURN**, then type **</TH>** (these tags create a table heading).
7) Position your cursor after the <TH> tag, press **RETURN**, then type **Date**.
8) Position your cursor after the </TH> tag and press **RETURN**.
9) Type **<TH>**, press **RETURN**, then type **</TH>**.
10) Position your cursor after the <TH> tag, press **RETURN**, then type **Event**.
11) Save your work, then open your file in an Internet browser.

Pachacuti (1438–1471), ruler of the Inca people of Peru, is born. Though primitive in some ways compared to Europe, the Incas were advanced in mathematics, astronomy, and agriculture.

Montezuma I (1440–1469), last of the great warrior kings of the Aztecs, is born. The Aztec empire covered most of the northern portion of modern Mexico.

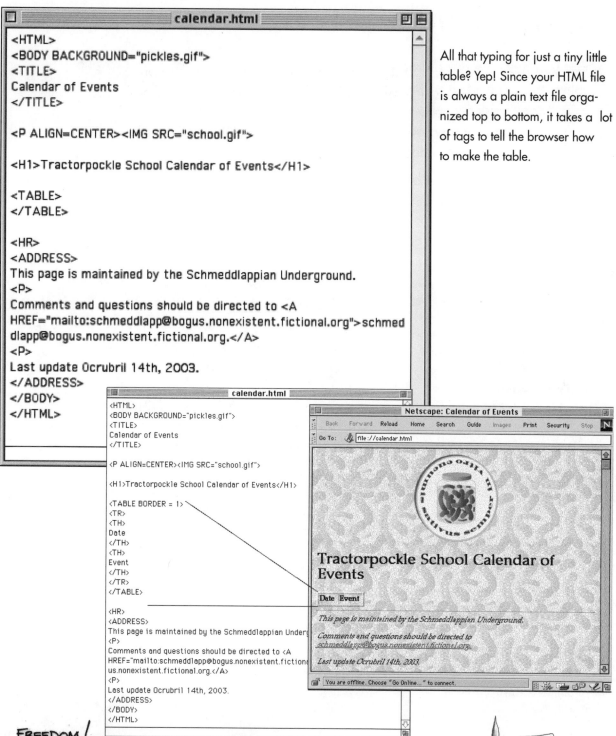

**calendar.html**

```
<HTML>
<BODY BACKGROUND="pickles.gif">
<TITLE>
Calendar of Events
</TITLE>

<P ALIGN=CENTER><IMG SRC="school.gif">

<H1>Tractorpockle School Calendar of Events</H1>

<TABLE>
</TABLE>

<HR>
<ADDRESS>
This page is maintained by the Schmeddlappian Underground.
<P>
Comments and questions should be directed to <A
HREF="mailto:schmeddlapp@bogus.nonexistent.fictional.org">schmed
dlapp@bogus.nonexistent.fictional.org.</A>
<P>
Last update Ocrubril 14th, 2003.
</ADDRESS>
</BODY>
</HTML>
```

All that typing for just a tiny little table? Yep! Since your HTML file is always a plain text file organized top to bottom, it takes a lot of tags to tell the browser how to make the table.

**calendar.html**

```
<HTML>
<BODY BACKGROUND="pickles.gif">
<TITLE>
Calendar of Events
</TITLE>

<P ALIGN=CENTER><IMG SRC="school.gif">

<H1>Tractorpockle School Calendar of Events</H1>

<TABLE BORDER = 1>
<TR>
<TH>
Date
</TH>
<TH>
Event
</TH>
</TR>
</TABLE>

<HR>
<ADDRESS>
This page is maintained by the Schmeddlappian Underg{
<P>
Comments and questions should be directed to <A
HREF="mailto:schmeddlapp@bogus.nonexistent.fictiona
us.nonexistent.fictional.org.</A>
<P>
Last update Ocrubril 14th, 2003.
</ADDRESS>
</BODY>
</HTML>
```

**Netscape: Calendar of Events**

Back  Forward  Reload  Home  Search  Guide  Images  Print  Security  Stop

Go To: file://calendar.html

# Tractorpockle School Calendar of Events

| Date | Event |
| --- | --- |

*This page is maintained by the Schmeddlappian Underground.*

*Comments and questions should be directed to schmeddlapp@bogus.nonexistent.fictional.org.*

*Last update Ocrubril 14th, 2003.*

You are offline. Choose "Go Online..." to connect.

FREEDOM!

The 1400s marks the beginning of the European slave trade with Africa. Over the next three and a half centuries, between 8 and 15 million African people are taken by force and sold in the Caribbean and the Americas.

Christopher Columbus makes landfall in the Americas, October 12, 1492. Prior European contacts, such as the Viking settlement in Nova Scotia in 1100, had left the New World virtually untouched. Columbus's arrival is the beginning of major European colonization.

UH....OHHH

Hernán Cortés (1485–1547) conquers the kingdom of the Aztecs.

1450-1807          1492

# Adding Rows to Your Table

Now that you have the basic structure and heading for the table, you'll add rows of information to it. The <TR></TR> tags show where each row begins and ends. The <TD></TD> tags mark the cells.

You can add as many rows as you like to your table. The Internet browser will keep extending the table to make room for everything you have to say.

## More Table Talk!

### Delimiter

The <TR> and <TD> tags are called *delimiters*. They show the Internet browser where one unit of information starts and stops. When you have a set of delimiters that everyone agrees to, computers can share not just information but the way it should be organized, categorized, and synthesized.

### White Space

You might have noticed that we're using a lot of RETURNS in the HTML files. They're not technically necessary, but putting in lots of white space makes it easier to skim the HTML file and find the information you want, in case you have to add or correct anything. You can put as much white space in your files as you like—the browser will ignore the extra spaces when it displays your page. White space includes spaces, tabs, and returns. So, these three lines:

```
    <TD>
    Stuff
    </TD>
```

will be treated exactly the same as:

```
    <TD>Stuff</TD>
```

## TO ADD ROWS TO YOUR TABLE

1) Position your cursor after the </TR> tag and press **RETURN**.

2) Type **<TR>** and press **RETURN**.

3) Type **<TD>Ocrubril 17</TD>** and press **RETURN**.

4) Type **<TD>Tractorpockle Picklepackers Tackle Hockey Popup Punting Really Peppy Preppie Rally</TD>** and press **RETURN**.

5) Type **</TR>** and press **RETURN**. This completes a row in the table.

   Now, following steps 1–5 again, add these rows:
   ```
   <TR>
   <TD>Justemberary 12</TD>
   <TD>Pickle Day</TD>
   </TR>
   <TR>
   <TD>Justemberary 32</TD>
   <TD>Fantastic Island Field Trip</TD>
   </TR>
   ```

6) Save your work, then open and view it in your browser.

Leonardo da Vinci (1452–1519), inventor, painter, scientist, engineer, sculptor, cartographer (mapmaker), and architect —*the* Renaissance man—is born. In addition to being the painter of the *Mona Lisa* and *The Last Supper,* Leonardo also invented an impractical model for a hang glider, and showed his great intellect by never actually trying it out. A Ninja Turtle is named after him.

Michelangelo Buonarotti (1475–1564) finishes painting the Vatican's Sistine Chapel. A sculptor and painter, Michelangelo's works include the statues of David and of the Madonna and Christ (called the *Pietà*). He spent four years (1508–1512) flat on his back painting the ceiling of the Sistine Chapel in Vatican City. A Ninja Turtle is named after him.

```
index.html

<P ALIGN=CENTER><IMG SRC="school.gif">

<H1>Mrs. Schmeddlapp's Sixth Grade</H1>
Hi! We're the Schmeddlappians, the cool sixth
graders of Mrs. Schmeddlapp's room here at
Tractorpockle School in Onomatopoeia, PA.

<H2>Announcements</H2>
This is an exciting year for all of us! Our
Tractorpockle Picklepackers are well on their
way to championships in both Tackle Hockey and
Popup Punting. Come cheer them on Ocrubril
17th at the 92nd annual Tractorpockle
Picklepackers Tackle Hockey-Popup Punting
Really Peppy Preppie Rally! Be sure to wear your
green garters!

<H2>Useful Links</H2>

<A HREF="
<P ALIGN=
<A HREF="
WIDTH=72

<P>
<HR>
<ADDRESS
This page
Undergrou
<P>
```

Once your table is started, it's easy to
keep adding rows using the pattern:

```
<TR>
<TD>Stuff</TD>
<TD>More Stuff</TD>
</TR>
```

You can put up a calendar for the full
year, or change it monthly.

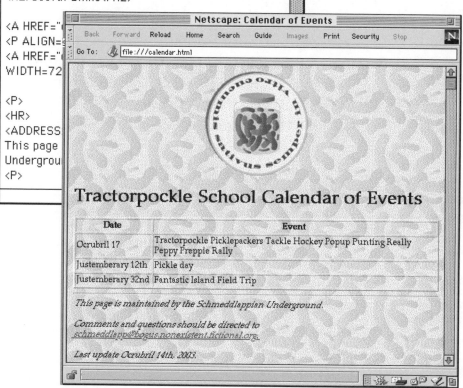

**Netscape: Calendar of Events**

Back   Forward   Reload   Home   Search   Guide   Images   Print   Security   Stop

Go To: file:///calendar.html

# Tractorpockle School Calendar of Events

| Date | Event |
|------|-------|
| Ocrubril 17 | Tractorpockle Picklepackers Tackle Hockey Popup Punting Really Peppy Preppie Rally |
| Justemberary 12th | Pickle day |
| Justemberary 32nd | Fantastic Island Field Trip |

*This page is maintained by the Schmeddlappian Underground.*

*Comments and questions should be directed to*
*schmeddlapp@bogus.nonexistent.fictional.org.*

*Last update Ocrubril 14th, 2003.*

DONETELLO, SCHMONETELLO!
NINJA, SCHMINZA!
I AM BENVENUTO THE
YOYO
DOMINATOR!

Benvenuto Cellini (1500–1571) was an artist of the Italian High
Renaissance (when everything was really cookin'). He was a
sculptor, goldsmith, and architect, but he is best known as a writer.
His autobiography (the story of his own life), finished in 1562,
was one of the first autobiographies to appear in western litera-
ture. Curiously, no Ninja Turtle is named after him.

# Linking Up Your Pages

Now that you've created the calendar, you need to link it up with the index page so that people can get from one to the other. This time we'll use a .GIF graphic as the link. Using a graphic image (picture, drawing, or the like) makes it easy for people to quickly locate the links by which they can navigate around your web site; images make your pages look consistent and well organized. To use an image, you put an <IMG> tag inside of an <A HREF> tag set. It's a good idea to include a text link as well as a picture link, because sometimes people have an easier time understanding words than pictures. Be careful, though: too many pictures can create clutter and distract users. You want to strike a balance between art, white space, and text to make an attractive page.

## Is Your GUI a CUI?

**Consistent User Interface (CUI)**
The main reason that Macintosh and Windows-based computers are easy to use is their graphic user interface (GUI). The icons, or pictures, that they use illustrate what particular tools do. For example, a folder stores files and a trash can deletes them.

But what if someone wrote a program that had a storage bin that looked like a trash can, or a "to be destroyed" folder that looked like a regular folder? People would accidentally throw away files that they want to keep!

Such a scenario shows that while having a graphic user interface is good, it's only good if it's a *consistent user interface,* too. That means that if a picture means one thing on one page, it should mean the same thing on every page. So, in our case, we're using a small school logo to point to the front page of the school web site: that means that every time we use that small picture, it should be a link back to the main page. Otherwise, our visitors might get confused when they click the logo and either stay where they are or go to some other page.

## TO LINK YOUR WEB PAGES

1) If necessary, reopen calendar.html with your text editor.

2) Position your cursor after </TABLE> and press **RETURN**.

3) Type **<HR>** and press **RETURN**.

4) Type **<A HREF="index.html">Go back to the Tractor-pockle School Home Page</A>** and press **RETURN**.

5) Type **<P ALIGN=CENTER>** and press **RETURN**.

6) Type **<A HREF="index.html"><IMG SRC="smallschool.gif"></A>** and press **RETURN**.
"smallschool.gif" can be found at www.draw3d.com.

7) Now open the index.html file in the text editor.
Replace the words "We'll add some useful links here" with:

**<A HREF="calendar.html">Calendar of Events</A>**
**<P ALIGN=CENTER>**
**<A HREF="calendar.html">**
**<IMG SRC="calendar.gif" WIDTH=72**
**HEIGHT=72></A>**
"calendar.gif" can be found at www.draw3d.com.

Ferdinand Magellan leads the first expedition to circumnavigate the globe. Circumnavigate is a long word that means "go around"—it means he sailed around the world.

Nicolaus Copernicus presents his theory of a heliocentric (sun-centered) solar system, which means that planets rotate around the Sun, rather than the Sun rotating around the Earth, as most people at the time believed.

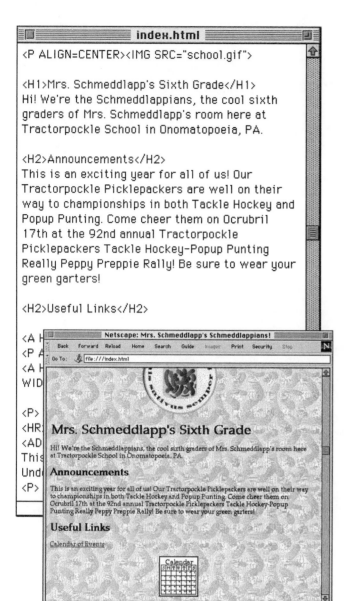

index.html

```
<P ALIGN=CENTER><IMG SRC="school.gif">

<H1>Mrs. Schmeddlapp's Sixth Grade</H1>
Hi! We're the Schmeddlappians, the cool sixth
graders of Mrs. Schmeddlapp's room here at
Tractorpockle School in Onomatopoeia, PA.

<H2>Announcements</H2>
This is an exciting year for all of us! Our
Tractorpockle Picklepackers are well on their
way to championships in both Tackle Hockey and
Popup Punting. Come cheer them on Ocrubril
17th at the 92nd annual Tractorpockle
Picklepackers Tackle Hockey-Popup Punting
Really Peppy Preppie Rally! Be sure to wear your
green garters!

<H2>Useful Links</H2>

<A H
<P A
<A H
WID

<P>
<HR>
<AD
This
Und
<P>
```

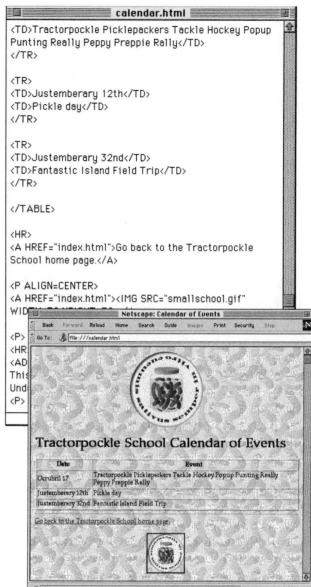

calendar.html

```
<TD>Tractorpockle Picklepackers Tackle Hockey Popup
Punting Really Peppy Preppie Rally</TD>
</TR>

<TR>
<TD>Justemberary 12th</TD>
<TD>Pickle day</TD>
</TR>

<TR>
<TD>Justemberary 32nd</TD>
<TD>Fantastic Island Field Trip</TD>
</TR>

</TABLE>

<HR>
<A HREF="index.html">Go back to the Tractorpockle
School home page.</A>

<P ALIGN=CENTER>
<A HREF="index.html"><IMG SRC="smallschool.gif"
```

Keeping the size and location of your navigation icons the same from page to page helps your visitors quickly find the information they want. It also makes it easier for you to create your web pages, since you don't have to decide on a special look for each page. Make your site interesting by changing the content, but keep the look and feel of your pages consistent.

William Shakespeare (1564–1616) wrote thirty-six plays, 154 sonnets, and 2 story poems. Four hundred years later, his plays are still considered by many the best ever written. He keenly understood human nature and told stories that are as true today as they were when he wrote them. He coined the phrase "catch a cold."

# Cool Sites!

Here are some great web sites by and about Renaissance renegades like you!

---

## Homework Tools

You're on the final page of the most brilliant term paper ever written, when you realize that you haven't got a stunning quote to sum up your main points. No problem! Zip out to the web and check out *Bartlett's Familiar Quotations*. While you're there, check your spelling with *Webster's Dictionary,* and check out *Roget's Thesaurus* to see if there's a synonym for "cool" that you haven't used yet.

**www.zen.org/~brendan/kids-homework.html**

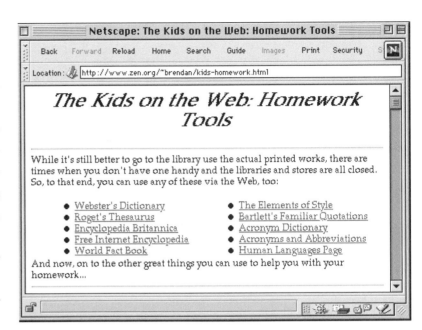

## Study Web

This is a great site for you and your teachers! Study Web features links to hundreds of web sites in every category you can imagine. Each of the links has been reviewed and rated to help you select the one that will help you most.

Don't let the name fool you, either. There's plenty of fun and games to be had by visiting these excellent teaching web sites.

**www.studyweb.com**

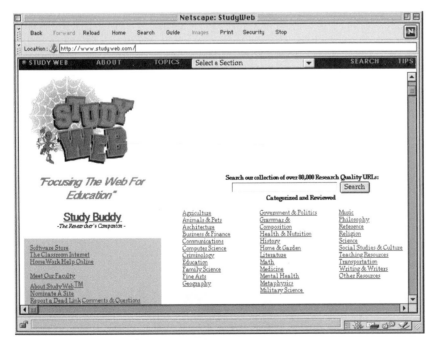

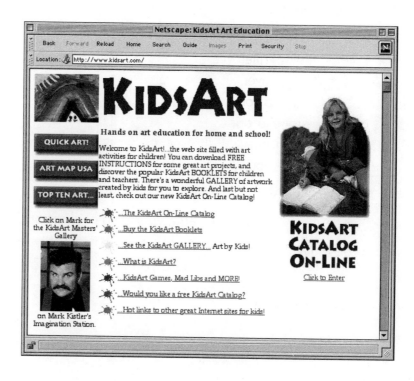

# KidsArt

Mark's good friend and frequent TV guest Kim Solga is the webmaster of a great spot for games and arts-and-crafts projects. There are sample projects from the excellent KidsArt line of educational materials, links to other art sites, and—what a surprise!—a gallery of kids' art!

**www.kidsart.com**

# Cool Sites Continued

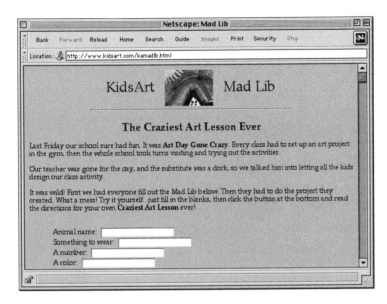

You can create your own cool art project (well . . . sort of) using the Mad Libs machine. Just type in a series of random words and you'll create your own incredible, if not impossible, art project to amaze your classmates.

There's also a terrific map of the United States that links you to regional crafts projects from all over the country.

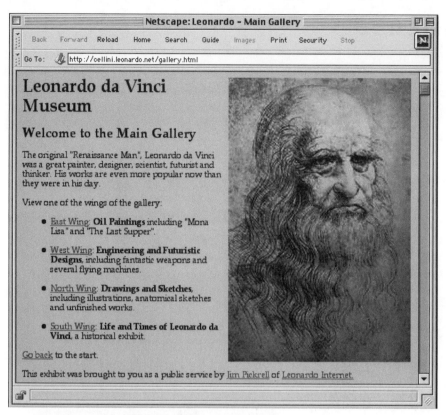

The browser window shows:

**Netscape: Leonardo - Main Gallery**

Back  Forward  Reload  Home  Search  Guide  Images  Print  Security  Stop

Go To: http://cellini.leonardo.net/gallery.html

# Leonardo da Vinci Museum

## Welcome to the Main Gallery

The original "Renaissance Man", Leonardo da Vinci was a great painter, designer, scientist, futurist and thinker. His works are even more popular now than they were in his day.

View one of the wings of the gallery:

- East Wing: **Oil Paintings** including "Mona Lisa" and "The Last Supper".

- West Wing: **Engineering and Futuristic Designs**, including fantastic weapons and several flying machines.

- North Wing: **Drawings and Sketches**, including illustrations, anatomical sketches and unfinished works.

- South Wing: **Life and Times of Leonardo da Vinci**, a historical exhibit.

Go back to the start.

This exhibit was brought to you as a public service by Jim Pickrell of Leonardo Internet.

A genius of the Italian Renaissance, Leonardo da Vinci (1452–1519) was a futurist (dreamer), artist (drawer), and engineer (doer!). You can learn all about him at the online da Vinci Museum.

The East Wing browser window shows:

**Netscape: Leonardo - East Wing**

**East Wing - Leonardo**

This area contains traditional oil paintings by Leonardo da Vinci. Larger views are available by clicking on the "postage stamp" images.

Angels and Landscape of the Baptism of Christ (c. 1473-8)

Florence, Uffizi

Oil on Wood Panel, 70" x 59"

When Leonardo worked under Verrocchio he participated in many works including this painting of two angels. Leonardo painted the angel on the left, which differs stylistically from its companion on the right. The background bears a close similarity to sketches Leonardo did of the Arno river valley. It is generally accepted as Leonardo's earliest surviving painted work. The painting was done for the monastery at San Salvi.

Leonardo's web site is divided into different museum "wings" in order to show off all of his art and mechanical designs. At the online da Vinci Museum, you can see the *Mona Lisa* and *The Last Supper,* even though they're actually hundreds of miles apart, in France and Italy, respectively.

# Cool Sites Continued

His designs for a helicopter and wings that would allow a man to fly like a bird didn't actually get off the ground, but other people used his ideas and built their own flying machines (you can see how much his wing looks like a modern hang glider). Sharing ideas gives others a chance to build on what you begin.

## Michelangelo

Learn all about one of the most beloved artists of all time at this amazing web site created by the web services company Michelangelo.com. While you're looking at the amazing works of art created by Michelangelo, pay attention to the artistry shown by the web designers who created the site!

**www.michaelangelo.com/ buonarotti.html**

## Surfin' with the Bard

Here it is: a complete site dedicated to the greatest playwright who ever lived. What's even better is that this site doesn't take itself too seriously—Shakespeare would have loved it! No one had a better sense of humor, and he would want his web site to be this fun and lively. Shakespeare on *Star Trek*? Shakespearean paper dolls? Check it out!

**www.ulen.com/shakespeare**

---

# What Have You Done?

You've learned how to use background images to create a consistent look and feel for your site. You've learned how to use tables to organize information in a horizontal format. You've learned that Renaissance persons like yourself are pretty cool! Now, we're going to turn your talents loose on your favorite service club. Not only are you doing great work, you're about to do great things!

# 4. Creating an Organization Homepage

Now, let's make a homepage for a club. This time, we're going to add cool features like music and animation. We will also use frames to divide the browser window into two parts so that we can keep a table of contents visible on the left at all times.

We'll begin by creating a couple of normal pages, an index page that will display the pages in frames, and a contents page to link them all together.

This homepage will feature my favorite service organization, the Arachnophiles (that's Greek for spider-lovers).

---

**TO START YOUR ORGANIZATION HOMEPAGE**

1) Create the two pages displayed here: arachnophiles.html and history.html. The graphics are available at www.draw3d.com, or you can create your own!

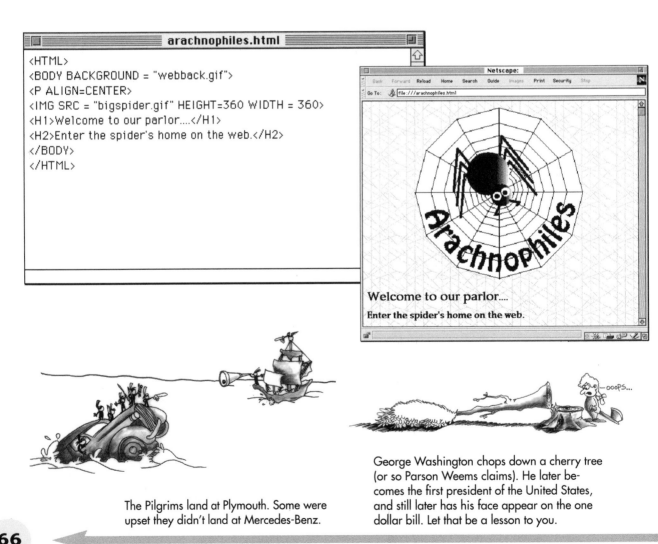

```
arachnophiles.html

<HTML>
<BODY BACKGROUND = "webback.gif">
<P ALIGN=CENTER>
<IMG SRC = "bigspider.gif" HEIGHT=360 WIDTH = 360>
<H1>Welcome to our parlor....</H1>
<H2>Enter the spider's home on the web.</H2>
</BODY>
</HTML>
```

The Pilgrims land at Plymouth. Some were upset they didn't land at Mercedes-Benz.

George Washington chops down a cherry tree (or so Parson Weems claims). He later becomes the first president of the United States, and still later has his face appear on the one dollar bill. Let that be a lesson to you.

```
<HTML>
<BODY BACKGROUND = "webback.gif">
<IMG SRC = "arachnophiles.gif" WIDTH= 158 HEIGHT=156 ALIGN=RIGHT>

<H1>About the Arachnophiles</H1>

The arachnophiles were founded in 1953 to promote understanding and
cooperation with spiders and all arachnids in the universe.
<P>
With the advent of the Internet, our mission was expanded to encourage
and participate in the growth of the World Wide Web, the natural home
for the most misunderstood of nature's beautiful creatures, the spider.
<P>
</BODY>
</HTML>
```

Notice that these two pages don't have <TITLE> tags. That's because we're going to put these pages into frames, which don't display titles for individual pages. Without a title, the window appears with only "Netscape": in the title bar; Explorer displays the filename.

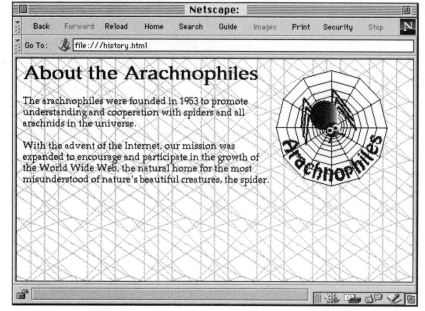

Benjamin Franklin (1706–1790): A real Renaissance man, though he was born about one hundred years too late. An inventor, statesman, philosopher, and printer, he invented bifocal eyeglasses and the Franklin stove, and he performed many practical experiments with electricity—without which we would have to surf the Internet by candlelight. His face appears on the hundred-dollar bill. Hmmmmm.

Around one hundred colonists dressed as Indians throw tons of British East India Company tea into Boston Harbor to protest unfair taxation. Harbor fish were disappointed that they didn't also protest the cost of sugar and lemon.

1752                    1773

# Anchors (the NAME parameter)

Most often, you'll want your visitors to start at the top of your web page and read to the bottom. Sometimes, though, your page might have specific topics that people will want to jump to right away. To make these pages easier to access, you can create link targets, which are called anchors.

Anchors are most useful when coupled with subheadings (<H2>, <H3>, and so forth), the two together making the page more organized and easier to navigate.

**What's in a Name?**

### <A NAME>

The NAME parameter of the <A> (address) tag is used to create anchors. You can think of them as bookmarks on the page that people can use to find the part they want to read.

To link to an anchor, you precede it with a pound symbol (#). So, to create an anchor named "ralph," I would use the tag <A NAME="ralph"></A>. To link to it, I use the address tag <A HREF="#ralph">Ralph</A>. To link from another page, I include both the file name and the anchor: <A HREF= "thepage.html#ralph">Ralph</A>.

## TO ADD ANCHORS TO YOUR WEB PAGE

1) Open history.html.
2) Save the file as **membership.html**.
3) Change "About the Arachnophiles" to **Join us!**
4) Highlight everything between the </H1> tag and the </BODY> tag (don't highlight either of these tags, though!). Press the **DELETE** (or **BACKSPACE**) key.
5) Now enter the text as shown in the example on page 63 (the full file is available online, too, at www.draw3d.com). You start by creating an ordered list with internal links to the anchors on the page. Then you create the anchors for each section using the <A NAME=> tag.

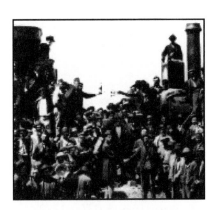

Samuel F. B. Morse (1791–1872) sends the first magnetic telegraph message, between Baltimore and Washington. This was the beginning of long-distance electronic communications. Asked for comment, Mr. Morse said only,
"— •••• •— —• —•— •••."

Matthew Brady (1823–1896) provides equipment for more than twenty photographers to record the American Civil War. The harsh reality of the images fueled antiwar sentiment on both sides and made the conflict more real to those who were safe at home.

On May 10, 1869, the transcontinental railroad was completed at Promontory, Utah, and marked by driving a golden spike to lay the last rail. At one point, 25,000 people were employed in building the rail line that would connect the country from coast to coast.

1844            1861-1865            1869

```
membership.html

<HTML>
<BODY BACKGROUND = "webback.gif">
<IMG SRC = "arachnophiles.gif" WIDTH=158 HEIGHT=156 ALIGN=RIGHT>
<H1>Join Us!</H1>
Joining the Arachnophiles is easy! There are four levels of membership, each with progressively
more stringent entrance requirements.

<OL>
<LI> <A HREF="#initiation">Initiation</A>
<LI><A HREF="#egg">Egg</A>
<LI><A HREF="#hatchling">Hatchling</A>
<LI><A HREF="#spinner">Spinner</A>
</OL>

<A NAME="initiation">
<H2>Initiation</H2>
To begin weaving the web of your Arachnophilia, write in 25 words or fewer exactly what it is you
like most about spiders. E-mail your answer to our webmaster, Taran Tula, and he will get back to
you within 26 hours to let you know if you're a member. While our entrance requirements are
strict, no one has been refused membership in our almost 50 years of existence.

<A NAME="egg">
<H2>Egg</H2>
As an Egg, you have achieved the first level of membership. You receive the "I Wove Webs!"
button, and may enter the on-line chat room to discuss our little furry legged friends. To advance
to the next level, you will be required to photograph all of the corners in your house to show that
there is a healthy spider living near the ceiling (mom will like this part, because it's a great way to
control household pests!).

<A NAME="hatchling">
<H2>Hatchling</H2>
Hatchlings may wear the very classy Black Widow t-shirt with the glow-in-the-dark fangs.
Hatchlings participate in local spider conventions and lobby the government to crack down on the
indiscriminate decimation of the nation's spiders by sloppy and uncaring exterminators.

<A NAME="spinner">
<H2>Spinner</H2>
Spinners are at the highest echelon of Arachnophile strata. The Spi
invitation only, and are the only members permitted to wear the ce
warmers. The exact duties of the Spinner are on a "need to know" b
benefits given to Spinners, including frequent fly-eater miles.
</BODY>
</HTML>
```

Here we're combining the ordered list, which you've already learned, with an <A> (address) tag. The result is a numbered list of links. Pretty cool!

**Netscape:**

Back  Forward  Reload  Home  Search  Guide  Images  Print  Security

Go To: file://membership.html

## Join Us!

Joining the Arachnophiles is easy! There are four levels of membership, each with progressively more stringent entrance requirements.

1. Initiation
2. Egg
3. Hatchling
4. Spinner

### Initiation

To begin weaving the web of your Arachnophilia, write in 25 words or fewer exactly what it is you like most about spiders. E-mail your answer to our webmaster, Taran Tula, and he will get back to you within 26 hours to let you know if you're a member. While our entrance requirements are strict, no one has been refused membership in our almost 50 years of existence.

You are offline. Choose "Go Online..." to connect.

WHOA.... 8 MILES AN HOUR, YOWEEEEE

Karl Benz (1844–1929) creates the first practical automobile with an internal-combustion engine. He then tears around town at a heart-thumping eight miles per hour. His mom tells him to slow down, for Pete's sake.

I AM LEONARDO DE'CAPPUCINO! I WANT MY LATTE!

THIS IS MARKS JOKE, NOT DAWSONS!

The *Titanic,* considered unsinkable by its builders, hits an iceberg and sinks in the chilly North Atlantic.

1886                                    1912

# Adding MIDI Music

MIDI music adds an audio component to accompany your visually spectacular web page. It's a neat feature that doesn't use a lot of memory or make your web page slow to download.

Some people who visit your site may prefer not to listen to sound (for example, they may be viewing in a library or classroom and not want to disturb the people around them). As a general rule, you should make your MIDI music available, but display controls that allow the user to start and stop the music when he or she wants to.

To add multimedia (music and video) elements to your web page, use the EMBED tag. The parameters will change, depending on the type of item you want to show, but usually you'll just need to put in the name of the item and its size. For our page here, you can find the file "itsy.mid" at www.draw3d.com, or you can write your own MIDI file.

---

## MIDI Tunes!

MIDI is an acronym for *Musical Instrument Digital Interface*. It was first created to allow computers to talk to external music devices, such as keyboards or drum machines. Now, most computers come with built-in MIDI synthesizers, so that you can play music directly from your computer speaker.

MIDI files are like sheet music for your computer. Just as text files are smaller and easier to download than voice recordings of the same material, MIDI music is much faster to download than CD-quality music recordings. Entire symphonies can be downloaded in a matter of seconds. Your browser's MIDI player then reads the music and plays it for you.

### TO ADD A MIDI FILE TO YOUR WEB PAGE

1) Open arachnophiles.html in your text editor.
2) After the <BODY> tag, type
   **<EMBED SRC="itsy.mid" LOOP=0 AUTOSTART=FALSE HEIGHT=50 WIDTH=200>**.
3) Save your work, close the file, then open the page in your web browser.
4) Click the **PLAY** button to hear the song.

Claude Monet (1840–1926) paints *Impression: Sunrise*. Louis Leroy, an art critic, jokes, "Since I am impressed, it must contain some sort of impression." This was the origin of the term "Impressionism," used to describe a movement in painting and music of the 1800s. Impressionist works try to capture images that change quickly, such as light, atmosphere, and mood.

Georges Seurat (1859–1891) creates his best known work, *A Sunday Afternoon on the Island of La Grande Jatte*. Seurat pioneered pointillism, the use of tiny dots of color to produce images, rather than blending the colors together. His paintings have a shimmering, colorful character all their own.

1872            1886

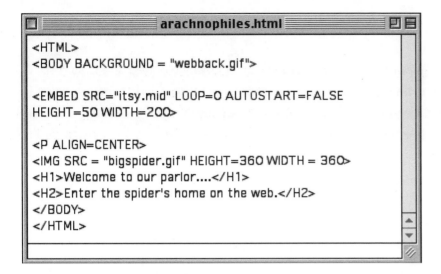

```
arachnophiles.html

<HTML>
<BODY BACKGROUND = "webback.gif">

<EMBED SRC="itsy.mid" LOOP=0 AUTOSTART=FALSE
HEIGHT=50 WIDTH=200>

<P ALIGN=CENTER>
<IMG SRC = "bigspider.gif" HEIGHT=360 WIDTH = 360>
<H1>Welcome to our parlor....</H1>
<H2>Enter the spider's home on the web.</H2>
</BODY>
</HTML>
```

LOOP tells the browser how many times to play the song. In this case, we don't want it to repeat, so we say 0. AUTOSTART tells the browser whether to play right away or to wait for your visitor to push the play button. In general, you always want to let your guest decide whether to play the music or not, so we'll set it to FALSE.

Beyond that, the EMBED tag looks pretty much like the IMG tag you've already mastered! In this case, the HEIGHT and WIDTH tags set the size of the MIDI player controls.

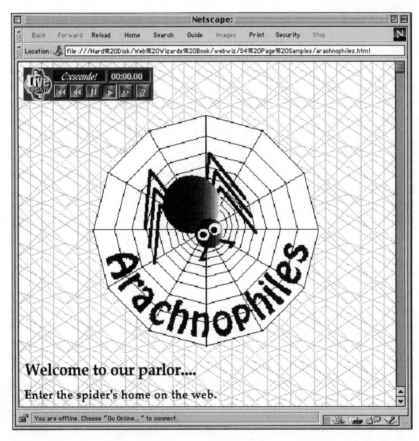

Claude Debussy (1862–1918) composes "Claire de Lune" (Moonlight), proving that he's not just another impressionable Claude.

Maurice Ravel (1875–1936). Compositions include "Pavane for a Dead Princess" and in 1922, his most well-known piece, "Bolero." He arranged Modest Mussorgsky's *Pictures from an Exhibition*, which is a series of Impressionist musical pieces based on paintings in a Russian gallery—the ultimate Impressionist work!

1890                                    1922

# Creating a <FRAMESET>

One way to maintain a consistent look and feel as people surf around your web site is to display a set of navigation controls that are always available. A great way to do this is to use frames to divide your web site into two or more panes. One of the frames is always displayed, showing links to get from one part of the site to another, while the other frame displays the pages as the user clicks the links.

---

### Framesets!

**<FRAMESET>**

<FRAMESET> defines the number of frames and their sizes. You use it in place of the <BODY> tag. COLS (short for columns) sets the width of your frame in pixels (usually seventy-two per inch) or as a fraction of the browser window. If you haven't learned about percentages yet, that's okay! Try different numbers from 10% to 90%, until it looks right. If you use an asterisk (`*`) for a column width, that means "whatever space is left over." In this example, we're using 30% of the window to display the table of contents, and the leftovers (70%) to display our spider pages.

The <NOFRAMES> text is displayed if the browser opening your page doesn't handle frames.

### TO CREATE A FRAMESET

1) Let's create a new HTML file. Enter your <HTML> and </HTML> tags.

2) Press **RETURN** after the <HTML> tag, then type **<TITLE>Arachnophiles Rule!</TITLE>**. Press **RETURN**.

3) Type **<FRAMESET COLS="30%,*">**. Press **RETURN**.

4) Type **<NOFRAMES>**, and press **RETURN**.

5) Type **The Arachnophiles web site requires a browser that displays frames**. Press **RETURN**.

6) Type **</NOFRAMES>**. Press **RETURN**.

7) Type **</FRAMESET>** and press **RETURN**. (The next line should be **</HTML>**.)

8) Choose File/Save As . . . create a new folder named "**arachnids**."

9) Save the file in the arachnids folder as **index.html**.

On March 10, 1876, Alexander Graham Bell (1847–1922) transmits the first message ever sent by telephone: "Mr. Watson, come here. I want you." Further experiments were delayed until he could get his teenager off the line.

Thomas Alva Edison (1847–1931) invents the phonograph, his favorite invention. He also created the incandescent lamp (lightbulb), the first centralized electric power station, flexible celluloid film, and the movie projector. He pretty much invented all the cool stuff.

1876                    1877

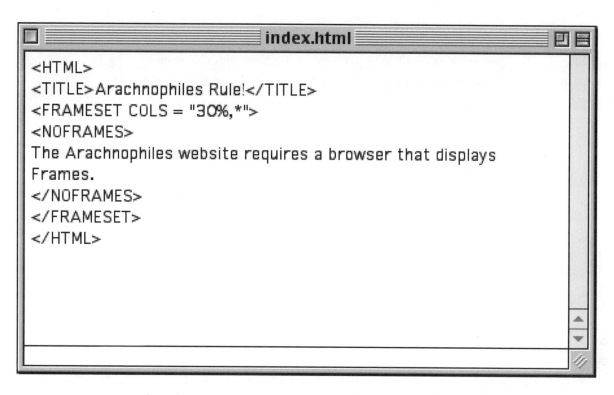

```
<HTML>
<TITLE>Arachnophiles Rule!</TITLE>
<FRAMESET COLS = "30%,*">
<NOFRAMES>
The Arachnophiles website requires a browser that displays
Frames.
</NOFRAMES>
</FRAMESET>
</HTML>
```

The index page isn't ready to display quite yet, so there's no example to show.

The <NOFRAMES> tag was more important than it is now when frames were first introduced. As you know, if a tag isn't supported, the browser just ignores it. In the case of frames, that would mean that nothing would show up at all! So having the NOFRAMES option lets you explain the situation to people who otherwise wouldn't have a clue what was wrong with your page. Frames have been supported for several years now, so the chances are actually rather slim that anyone will come to your site without a frame-capable browser. But you never know . . .

On December 17, 1903, Orville and Wilbur Wright perform the first successful heavier-than-air flight. It lasts twelve seconds and covers about 540 feet. No in-flight movie.

Henry Ford (1863–1947) begins using an assembly line to mass produce his Model T automobile. Workers each perform only one task in the car's construction as it moves by on a conveyor belt. Cars become cheap enough for most people to afford them.

Walter Elias Disney (1901–1966) produces the first sound cartoon, *Steamboat Willie*, starring Mickey Mouse.

1903    1913    1927

# Creating the Frames

Working with frames presents a "chicken or egg" situation: Do you create the frameset first, or do you make the files that go into it? It doesn't really matter, but you have to do a little planning ahead so that you name everything in a way that's easy to remember and use the correct names to load the files.

---

## <FRAMES>

The FRAME tag uses two parameters we've seen before. The SRC parameter works the same way as it does in the IMG tag: it identifies the file you want to display.

The NAME tag is used in the <A> tag to create an anchor. Here, it's used to give the frame a name. You'll use the frame's name when you create the table of contents in the next lesson.

### CONTINUING WITH FRAMES

1) If necessary, reopen the file index.html in your text editor.

2) Position your cursor after the <FRAMESET> tag and press **RETURN**.

3) Type **<FRAME SRC="toc.html"NAME="toc">** and press **RETURN**.

4) Type **<FRAME SRC="arachnophiles.html"NAME="stuff">**.

5) Save your work.

Frank Conrad receives a license to start KDKN in Pittsburgh, the first modern radio station with scheduled programs of music, sports, and some prank phone calls. Well, not really—just music and sports.

David Sarnoff demonstrates a television system at the New York World's Fair. Franklin D. Roosevelt becomes the first—but certainly not the last—American president to speak on television.

NTSC color television is introduced to the consumer market, but takes more than ten years to catch on. People just weren't that colorful, I suppose.

1920          1939          1953

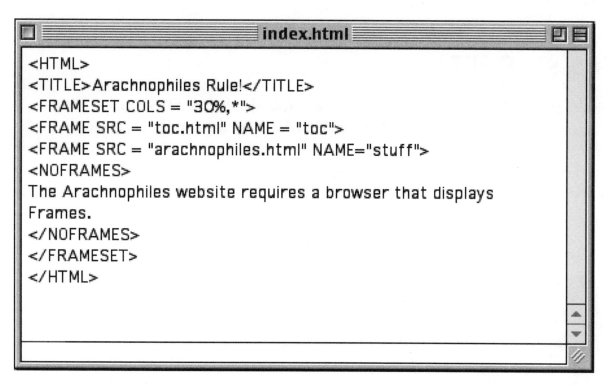

```
<HTML>
<TITLE>Arachnophiles Rule!</TITLE>
<FRAMESET COLS = "30%,*">
<FRAME SRC = "toc.html" NAME = "toc">
<FRAME SRC = "arachnophiles.html" NAME="stuff">
<NOFRAMES>
The Arachnophiles website requires a browser that displays
Frames.
</NOFRAMES>
</FRAMESET>
</HTML>
```

I've named the frames using all lowercase, mostly to save trouble when typing them later on (no need to keep using the shift key). I named the frame where we'll show the files "stuff." You could name it "Filbert" or "blanket" or "lambada" or anything you like; the important thing is to give the frame a name that will remind you what you wanted to use the frame for in the first place. In keeping with that, "toc" is a good name for the table of contents; and since all of the other stuff goes in the second frame, why not just name it "stuff"?

Communications satellites make it possible for events to be broadcast around the world as they happen.

Cellular phones are introduced, providing convenience—because you can always reach your friends by phone—and annoyance, because your friends can always reach you by phone.

Sixty-five percent of American homes are wired for cable television, offering viewers hundreds of options. Channel surfing becomes a popular sport.

1960s      1981      1995

# Creating the Table of Contents Using <TARGET>

Files displayed in frames are the same as any other HTML files you might create. You can display graphics, play sounds, and link to other files through them. But if you click a link in a frame, the browser needs to know which frame to use when it displays the new file. You tell it which frame to use with the TARGET parameter. We'll learn the TARGET parameter by creating a table of contents frame for our site.

**Target**

The TARGET parameter tells the browser which of the frames should be used to display the file in the link.

When you link to pages within a web site, it's best to consistently display them in one frame, usually the largest.

If you link to pages outside of your web site (see page 36), you can use the TARGET tag to display them in one of your frames, or you can set the target to "_top" to leave the frameset and display the page in the full browser window.

## TO CREATE THE TABLE OF CONTENTS

1)  Type the file as shown in the example on page 71. Now, let's take a minute to look at just one of the lines and decipher what it tells the browser:

    <LI> <AHREF="membership.html#egg"TARGET="stuff">Egg</A>

| | |
|---|---|
| **<LI>** | Include this line in the list. |
| **<A HREF="membership.html"** | |
| | Open the file membership.html. |
| **#egg** | Jump to the anchor egg. |
| **TARGET="stuff">** | |
| | Display the page in the frame titled "stuff." |
| **Egg** | Use this as the hyperlink word. |
| **</A>** | End the link. |

2)  Save the file as toc.html.
3)  Open index.html in your web browser to see toc.html and arachnophiles.html together on the same page!

ENIAC (Electronic Numerical Integrator and Computer), the first successful electronic computer, makes its debut. It used eighteen thousand vacuum tubes to process its calculations, and could calculate a cannon's target range faster than the cannon could hit it. This didn't actually make much difference to the target, however.

UNIVAC I, the first programmable computer, is offered to consumers. It's used by the Census Bureau to add up the number of people in the country.

1946                                                        1951

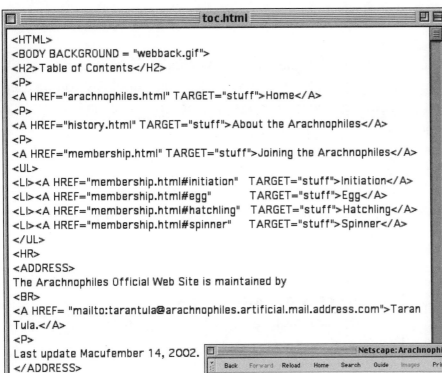

```
toc.html

<HTML>
<BODY BACKGROUND = "webback.gif">
<H2>Table of Contents</H2>
<P>
<A HREF="arachnophiles.html" TARGET="stuff">Home</A>
<P>
<A HREF="history.html" TARGET="stuff">About the Arachnophiles</A>
<P>
<A HREF="membership.html" TARGET="stuff">Joining the Arachnophiles</A>
<UL>
<LI><A HREF="membership.html#initiation"  TARGET="stuff">Initiation</A>
<LI><A HREF="membership.html#egg"         TARGET="stuff">Egg</A>
<LI><A HREF="membership.html#hatchling"   TARGET="stuff">Hatchling</A>
<LI><A HREF="membership.html#spinner"     TARGET="stuff">Spinner</A>
</UL>
<HR>
<ADDRESS>
The Arachnophiles Official Web Site is maintained by
<BR>
<A HREF= "mailto:tarantula@arachnophiles.artificial.mail.address.com">Taran
Tula.</A>
<P>
Last update Macufember 14, 2002.
</ADDRESS>
</BODY>
</HTML>
```

By mixing together the tags you've already learned, you can create a very cool web page! Don't be afraid to try new combinations and make your own unique designs.

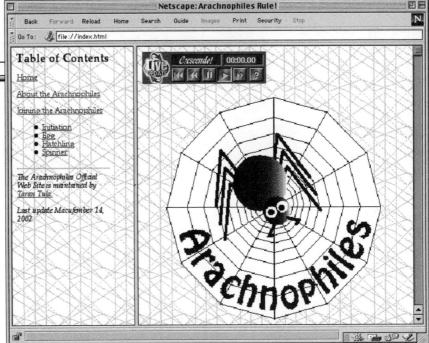

Apple Computer produces its first personal computer.

Bill Gates and Paul Allen create MS-DOS (Microsoft Disk-Operating System). Many people use it, and Bill becomes one of the richest men in the world.

The European Organization for Nuclear Research creates the World Wide Web.

1977

1980

1990

# Adding a GIF Animation

GIF (graphics interchange format) images are designed to be downloaded in layers. This permits interlacing, which makes images display gradually as they're loaded. The capability can be used to create an animated cartoon, by loading several images in order, one over the other. In a minute, we'll add a GIF animation to our page.

One way to obtain GIF animations is to download them from other people's web sites. That's great, if you have permission. If you don't ask first, though, taking text, sound, or pictures from a web site is stealing (it's against the law, but more than that, it's not nice to take other people's work without asking). You'll find that most people are happy to share their work with you, if you ask nicely and offer to share your pictures with them!

---

## Interlacing

GIF images can be created as *standard* or *interlaced* images. Standard images load from top to bottom. Interlaced images load a few dots at a time from each line of the drawing. As a result, you get a sense of what the entire image will look like when it finishes loading, and the detail improves as more of the graphic is loaded into memory. Either way, the images take about the same amount of time to load and end up looking the same.

### TO PLACE A GIF ANIMATION

1) Download the file eensy.gif from www.draw3d.com and save it in the same directory as toc.html.
2) Open the file toc.html in your text editor.
3) Position your cursor after the <BODY> tag and press **RETURN**.
4) Type **<IMG SRC="eensy.gif" ALIGN=RIGHT WIDTH=54 HEIGHT=131>**
5) Save your work.
6) Open the file index.html with your web browser.

Sputnik is launched by the Union of Soviet Socialist Republics, initiating the space race.

John Glenn is not the first animal in space (that was Laika the dog) or the first human in space (Yuri Gregarin), but he is the first human to *orbit* the Earth (U-S-A! U-S-A!).

Neil Armstrong, commander of Apollo 11, is the first person to walk on the moon. "One small step for a man, one giant leap for mankind."

1957            1962            1969

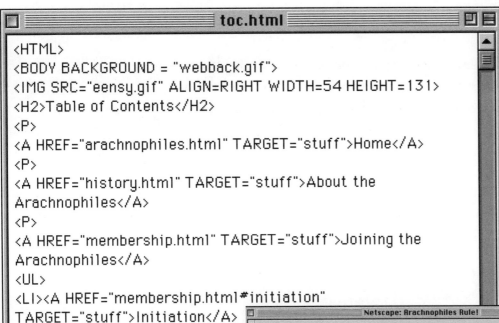

```
<HTML>
<BODY BACKGROUND = "webback.gif">
<IMG SRC="eensy.gif" ALIGN=RIGHT WIDTH=54 HEIGHT=131>
<H2>Table of Contents</H2>
<P>
<A HREF="arachnophiles.html" TARGET="stuff">Home</A>
<P>
<A HREF="history.html" TARGET="stuff">About the
Arachnophiles</A>
<P>
<A HREF="membership.html" TARGET="stuff">Joining the
Arachnophiles</A>
<UL>
<LI><A HREF="membership.html#initiation"
TARGET="stuff">Initiation</A>
```

The tag for an animated GIF is the same as the tag for a normal GIF. The difference is in the file, not in the HTML tag. There are many ways to add animation to your web pages, but GIF animations are probably the easiest and least expensive to make and download.

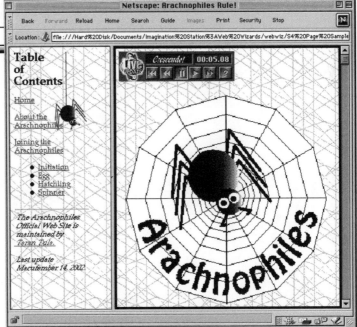

The U.S. launches the *Skylab* space station into orbit. It provides spectacular pictures of the comet Kohoutek, but it falls to Earth prematurely in 1979.

In the first space shuttle mission, the *Columbia* takes off on April 12 and returns to Earth on April 14.

At age seventy-seven, John Glenn becomes the oldest person ever to orbit the Earth. Construction of an international space station begins.

1973                    1981                    1998

# The Future and Beyond!

Congratulations, Web Wizard! You're on your way to becoming a genuine Webmaster! What does the future hold for you? Read on!

---

## HTML Updates

HTML is always being revised and improved by the World Wide Web Consortium (W3C). You can visit their homepage www.w3.org, where you will find lots of tips and information about using HTML, plus the listings of all the latest tags that are (or will be) supported by the leading web browsers. This book can only give you an overview of the basic tags you'll use most often—the W3C page gives you the complete story, up-to-the-minute and from the cutting edge.

## VRML

VRML stands for Virtual Reality Markup Language, which is used to create three-dimensional environments on the web. With VRML, you can "walk" or even fly around web sites, zooming in and out of virtual buildings, crossing alien landscapes, or whatever the developer can dream up. New tools are being developed that make it easier than ever to create your own 3-D worlds on the Internet. Visit the VRML Consortium homepage at www.web3d.org.

You are the first person to graduate from Harvard with advanced degrees in every subject. You're the captain of several sports teams and have the lead in the campus production of the ballet *Swan Lake*.

As you step out of your spacecraft onto the surface of Mars, you comment, "It's red. Really, really red."

Congress passes special legislation enabling you to become history's first six-term president.

2007                    2012                    2020

## Java

Java is a language used by programmers to create small applications, called Applets, that run on web browsers. In the past, computer programs had to be written for specific computers: if you wanted your program to run on Macintosh, you wrote a Macintosh version; if you wanted the same program to run on a PC-compatible computer, you had to write a completely different program for that computer; and so on for any other computer you can name. That is cumbersome for applications intended for the Internet, which is supposed to be accessible by all computers.

Enter Java. Java programs run in software called a "virtual machine" (JVM). The JVM for the Macintosh understands how to run a Java program, and the JVM for the PC-compatible computer understands how to run the same Java program. Obviously, this is a real benefit to both the developer, who only has to write one program, and to the users, who can use the program no matter what kind of computer they own.

Java programs can be created as plain text files and compiled (translated from human language to computer language) using software that is distributed without cost. You can find out more about Java software by visiting http://java.sun.com.

## JavaScript

JavaScript is a programming language that works within web browsers. It's simpler to learn, but not as powerful as Java. It's designed to work specifically within web pages, and while it doesn't actually have a lot in common with Java programming, it's a good place to start if you've never done any computer programming at all. You can learn more about JavaScript by visiting http://developer.netscape.com/tech/javascript.

After your tenure as president, during which you have secured lasting world peace for future generations, you leave office to become a character actor.

Your television series, *My Plumber the Prez*, is cancelled in spite of high ratings.

You continue to entertain your great-grandchildren with amusing anecdotes of when television was only three-dimensional and people ate by chewing and swallowing.

2040                    2055                    2098

# Cool Sites!

Here are some space-age sites to set your imagination soaring!

---

## You Can!

Based on the popular comic strip by Jok Church, here is a fabulous web site that takes advantage of what the Internet has to offer over a book or newspaper. Sure, there's lots of great information, but there are also interactive animated games and demonstrations that make science come alive for you. There are also instructions for experiments you can conduct in your own home.

**www.youcan.com**

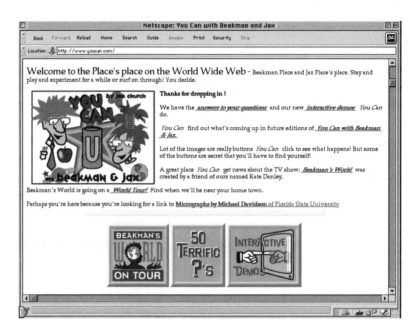

## The Franklin Institute

Founded in 1824, the Franklin Institute has been in continuous service to science for 175 years. The site is continually updated with information about current exhibits at its museum, as well as some "exhibits" that only appear on the Internet. In this screen capture, for example, is a picture of the Wright brothers' plane, taken at Kitty Hawk on the day of their historic flight. This photo was part of an online exhibit called Flights of Inspiration, about great feats in aviation.

You can also learn to set up your own weather station in your backyard, using the tools and techniques in the Franklin's Forecast section. If you can't get to Philadelphia to check this museum out, doing it online is the next best thing!

**www.fi.edu**

## Exploratorium

The Exploratorium in San Francisco, California, was one of the first museums to say, "Go ahead, touch everything!" This web site consistently wins awards for its innovative web exhibits. Go ahead, touch it—it's okay!

**www.exploratorium.edu**

## The Virtual Cave

Go spelunking (cave-exploring) online! The Virtual Cave features unique and dazzling pictures taken by site hosts Dave Bunnell and Djuna Bewley. These are images you're not likely to see anywhere else: the site takes you on a tour of an idealized cave, with examples of all the major speleothems (mineral deposits in interesting shapes) found in caves around the world. **www.goodearth.com/virtcave.html**

**Oh**, and go check out www.si.edu. Trust me, just do it. Wow. **www.si.edu**

# What Have You Done?

You've learned how to create web pages!

The best way to keep learning is to go out surfing the Net to find pages that you think look cool. Use the browser command View, Page Source to look at the HTML code used to create pages you like. Don't steal anyone's content—the text and pictures represent their hard work, and you shouldn't use other people's things without asking permission. You can, however, look at their HTML code, copy and paste it into your own HTML documents, and add your own content. That's how people learn, by copying and building on the work of other people they admire. If you have questions or ideas you want to share, you can always reach me through *Mark Kistler's Imagination Station* web site at **www.draw3d.com**. See ya on the Net!

# The Sorceror's Appendix A

## Cheat Sheets!

Okay, dudes and dudettes, now you're ready to create some cool web pages of your own. But that doesn't mean you have to start from scratch! Here are some templates you can use to get started.

## The UltimaTeacher Page!

Is your teacher the coolest person ever to walk on this planet? Does your teacher put up with thirty out-of-control web geniuses every hour of every day? Why not put up a tribute to this hero of the chalkboard?

   Start by asking a selected favorite teacher some questions like these:

> **How long have you been teaching? How long at this school?**
> **Why did you want to become a teacher?**
> **Where did you go to college? What were your favorite subjects when you were in school?**
> **Who was your favorite teacher when you were in school?**
> **What's the funniest thing that ever happened in your classroom?**
> **What advice would you give someone who wanted to be a cool teacher like you?**
> **If you weren't a teacher, what would be your second choice for a dream job?**
> **Do you have any hobbies? What else do you like to do besides assigning homework to innocent young children?**
> **What would you like me to put on your web page that we haven't already talked about?**

Now, create an HTML file like the one on page 79, with the answers filled in! Any place you see ##TEACHER##, replace it with the teacher's name. Replace ##ANSWER## with the answer to each question. The picture is optional—don't skip doing the page just because you don't have a picture. If you can't get a photograph, draw one! If you include a graphic, be sure to set the height and width.

```
<HTML>
<TITLE>UltimaTeacher: ##TEACHER##</TITLE>
<BODY BGCOLOR="White">
<H1>An Interview with ##TEACHER##</H1>
<IMG SRC="teacher.gif" HEIGHT=144 WIDTH=100 ALIGN="RIGHT">
<DL>
How long have you been teaching? How long at this school?
<DD>##ANSWER##

<DT>What made you want to become a teacher?
<DD>##ANSWER##

<DT>Where did you go to college?
<DD>##ANSWER##

<DT>What were your favorite subjects when you were in school?
<DD>##ANSWER##

<DT>Who was your favorite teacher when you were in school?
<DD>##ANSWER##

<DT>What's the funniest thing that ever happened in your classroom?
<DD>##ANSWER##

<DT>What advice would you give someone who wanted to be a cool teacher like you?
<DD>##ANSWER##

<DT>If you weren't a teacher, what would be your second choice for a dream job?
<DD>##ANSWER##

<DT>Do you have any hobbies? What else do you like to do besides
    assigning homework to innocent young children?
<DD>##ANSWER##

<DT>What would you like me to put on your web page
    that we haven't already talked about?
<DD>##ANSWER##

</DL>
<HR>
This page prepared ##DATE## by
    ##YOUR NAME##
</BODY>
</HTML>
```

# The Family Tree Page

Hey, why should you be the only one in the family who's cruisin' the information superhighway? Get the whole family involved by having them fill in, or at least appear in, a family tree on the web.

This kind of page is usually more interesting for the people who put it together than it is for the world at large, but there's nothing wrong with that! We'll set up a table where you can list your family back to your great-great-grandparents.

Some people draw their family trees with themselves at the bottom and the rest of the family branching off above them. In this case, you can think of your parents and grandparents as the roots from which you grew, and your children and their children will be the branches of the tree that spread out above you!

Once you've filled in your tree, you can create links from each of the cells to special pages about your mother, father, grandparents, and so on. You can link from your grandparents to aunts, uncles, and cousins. You can create an entire network of family history and stories. Wouldn't that be something to hand down to your children!

For this page, we're going to create a table that has cells of different sizes, some of which will spread across (or span) several columns. The lower you go, the more columns you'll have and the more relatives you can slip in there!

The special parameter you'll use is COLSPAN, which controls how many columns a cell will stretch across. The first row will have one cell with a COLSPAN of 8 (that means one cell spans across eight columns). The second row will have two cells with a COLSPAN of 4, the third row will have four cells with a COLSPAN of 2, and the bottom row will have 8 cells—one in each column, so no COLSPAN parameter is needed.

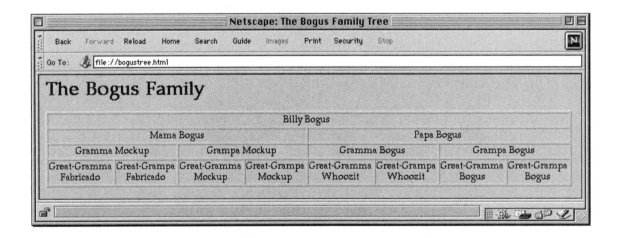

```
<HTML>
<TITLE>The Bogus Family Tree</TITLE>
<BODY BGCOLOR="#77FF77">
<H1>The Bogus Family</H1>
<TABLE BORDER=1 WIDTH=300>
<TR ALIGN=CENTER>
<TD COLSPAN=8 ALIGN=CENTER>Billy Bogus</TD>
</TR>
<TR ALIGN=CENTER>
<TD COLSPAN=4>Mama Bogus</TD>
<TD COLSPAN=4>Papa Bogus</TD>
</TR>
<TR ALIGN=CENTER>
<TD COLSPAN=2>Grandma Mockup</TD>
<TD COLSPAN=2>Grandpa Mockup</TD>
<TD COLSPAN=2>Grandma Bogus</TD>
<TD COLSPAN=2>Grandpa Bogus</TD>
</TR>
<TR ALIGN=CENTER>
<TD>Great-Grandma Fabricado</TD>
<TD>Great-Grandpa Fabricado</TD>
<TD>Great-Grandma Mockup</TD>
<TD>Great-Grandpa Mockup</TD>
<TD>Great-Grandma Whoozit</TD>
<TD>Great-Grandpa Whoozit</TD>
<TD>Great-Grandma Bogus</TD>
<TD>Great-Grandpa Bogus</TD>
</TABLE>
</BODY>
</HTML>
```

GREAT GRANDPA THROG!

WE LOVE THROG! YES WE DO!

HEY THROG! YOUR TAIL IS TEN TIMES AS TERRIFIC AS TINA'S TANGLED TWITCHING TINY TASSEL!

WE BRING YOU THE GREAT TWINKIE OF PEACE!

# JavaScript Jive

Okay, gang, I'm not going to try to teach you JavaScript in one page (there are whole books written about how to create JavaScript programs!). However, I *can* show you a pretty nifty trick that's easy to do. It just might whet your appetite to look more deeply into that JavaScript jive.

JavaScript is a programming language a little more sophisticated than HTML, but not much. In fact, it's designed as an extension of the HTML tags you already know. We're going to use a couple of very simple tags that will make a page of riddles and buttons that show the answers. These are the tags we'll use:

| | |
|---|---|
| <SCRIPT></SCRIPT> | These tags go at the beginning and end of our JavaScript. |
| <FORM></FORM> | These tags go at the beginning and end of the questions we want to appear on our form. |
| <INPUT> | Input is something that PUTs information INto the computer's memory. |
| Parameters: | This is the list of parameters, or values, that we'll use with the INPUT tag. |
| TYPE | There's more than one way to put information into the computer. "Types" of inputs include buttons, which we'll use here. |
| VALUE | The value means different things, depending on the type of INPUT. In this case, VALUE is the label, or text, that will appear on our buttons. |
| onclick | This tells the program what it should do (which of the functions it should perform) when the button is clicked. |
| function | This tells the program how it should do what it's told to do. |
| answer1, answer2, . . . | These are the names of the functions we've written. They can be any name you like, but it's usually best to name them something simple so that you can remember what they do. |

This is how the program works:

- **When you click the button, the onclick parameter tells your web browser which function it should look for.**
- **The function displays a dialogue box called an alert (it's called an alert because it just calls something to your attention—you don't have to do anything but click OK to make it go away).**
- **The note that you put in quotation marks is displayed in the alert.**

You can make as many joke buttons as you like—just keep increasing the number on the answer function. And I hope that you can think of better riddles than I did!

```
<HTML>
<BODY BGCOLOR="#FFFFFF">
<H1>Laugh-a-dacious Rollicking Good Times Riddle Page You Betcha!</H1>
<FORM>
What's gray and looks like gunpowder?
<INPUT TYPE="button"VALUE="I give up!"onclick="answer1()"><P>
Why did the elephant wear green tennis shoes?
<INPUT TYPE="button" VALUE="I don't know!"onclick="answer2()"><P>
Why did the elephant wear tennies in the first place?
<INPUT TYPE="button"VALUE="That's a tough one!"onclick="answer3()">
</FORM>
<SCRIPT>
function answer1() {
alert("Instant Elephant!")
}
function answer2() {
alert("Because his blue ones were in the wash!")
}
function answer3() {
alert("Ninies were too small and elevenies were too big!")
}
</SCRIPT>
</BODY>
</HTML>
```

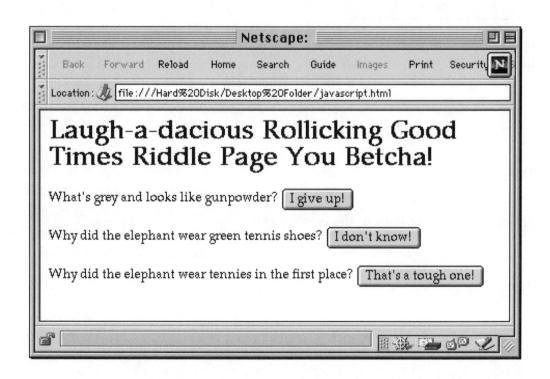

# The Sorceror's Appendix B

 **Is for Basics**

I know that for some of you, even creating a text file is a new experience. So let's take just a minute to walk and talk through the basics, and soon you'll be writing web pages with the best of us!

You may wonder why I'm teaching you to use just a plain word processor rather than an HTML authoring tool. There are two reasons. The first is that I haven't found an authoring tool that I liked better than writing HTML "from scratch." Though some are good, I find they all add extra, unnecessary tags to the final product that cause me headaches in the long run. The second reason is that even if you choose to use an HTML authoring package, you'll be more successful with it if you know what basic HTML code looks like, and you'll be better able to judge whether the package is right for you. Besides, text editors come free with your computer! I will describe the process for using SimpleText on the Macintosh computer, but with the exception of a couple of key names, the steps are the same in Notepad on the PC.

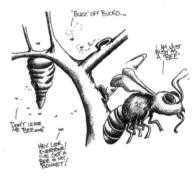

### Creating a Plain-Text HTML file

Locate the SimpleText program on your computer's hard disk. Open it: either double-click (click twice) on the icon, or click it once to select it, then choose the Open command from the File menu.

When you first open the word processor, you will see an empty page and a flashing vertical line. That line is called the cursor. Whatever letter you press on the keyboard will appear at the flashing cursor. The cursor then moves to the right for the next letter. When you reach the right-hand edge of the window, the cursor moves down to start a new line (this is called "word wrap"). Unlike on a typewriter, you don't need to do anything at the end of the line: allow the word wrap to move you down to the next line. Continue typing until you have completed a paragraph. Then press the **RETURN** key. (On a PC, press the **ENTER** key.)

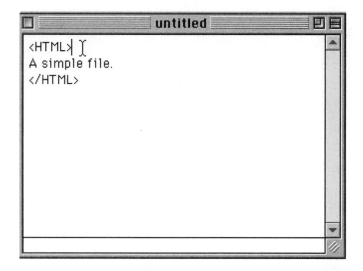

When you move the mouse, the pointer takes the shape of an "I-beam." The I-beam cursor is thin enough to fit between the letters in your file. You use the I-beam to move the flashing cursor around your document so that you can make changes to existing text. Place the I-beam at the point where you want to add text, click once, and the flashing cursor moves to the new position. If you want to add a line to your file, click at the end of the line above the place where you want the new line to appear . . .

. . . and press RETURN. The new line is inserted, and you can begin typing once more at the flashing cursor.

In some programs, including SimpleText, the I-beam cursor disappears while you type. That's to prevent it from blocking your view of the letters underneath it. The I-beam will reappear as soon as you move the mouse, ready to move the flashing cursor to another part of the document.

If you make a mistake, you can remove the problem letters by placing your cursor to their right, then pressing the **DELETE** key (**BACKSPACE** on the PC) to remove one letter at a time.

```
<HTML>
a mistekk
A simple file.
</HTML>
```

If you have several words to remove, a faster method is to click to the left or right of the offending passage, hold down the mouse button, and drag across the letters you want to remove. The words become highlighted—either marked with a pastel color, or reversed so that the text is white on black. Once you've highlighted the text you want to remove, release the mouse button, and press the **DELETE** key to remove it.

If you want to replace the highlighted letters with a different word, release the mouse button, and begin typing without pressing **DELETE**; the new letters will replace the old.

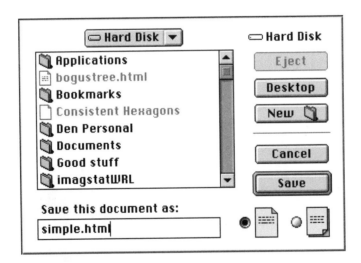

When you have completed the file to your satisfaction, go to the File menu and choose the Save As . . . command. The Save dialogue box appears, showing the current directory and a default name for the file. Highlight the file name and enter your own name for the file. To ensure that the file will be recognized as an HTML file on PC-compatibles, end the file name with the .html extension.

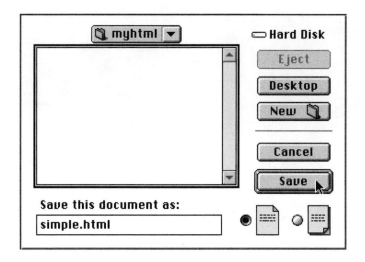

Use the pop-up (or pull-down, as the case may be) menu at the top of the
Save window to move up through the list of folders on your computer, or select
a folder (also called a directory) where you want the file to be stored. Be care-
ful to save your file in the correct folder so that you'll know where to find it! (If
a file is "lost," it's usually just in the wrong folder.) Click the SAVE button to
store your file in the selected directory.

----

To people under the age of twenty, this probably seems like a lot of unneces-
sary detail. But most of the people in the business world today, myself in-
cluded, never used a personal computer until they were out of college. With a
little practice, anyone can use a personal computer with ease, and have a lot
of fun in the process!

# The Sorceror's Appendix C
# Mark Kistler School
# Assembly and Product
# Information

## About Mark Kistler

For the past eighteen years, Mark Kistler has been teaching millions of children how to draw in 3-D at over 7,000 elementary school assemblies around the world, including teaching tours through Australia, Germany, England, Scotland, Mexico, and the United States.

He has starred in three hit children's public television *Learn to Draw in 3-D* series. These dynamic shows have been broadcast around the world in seventeen countries. His television programs include *The Secret City, The Draw Squad,* and *Mark Kistler's Imagination Station.* Over 40 million children globally have experienced the joy of 3-D drawing from these broadcasts. *Mark Kistler's Imagination Station* is broadcast on public television stations across the United States. For your local broadcast schedule, check your local listings or visit Mark Kistler's web site at **www.draw3d.com**

Mark Kistler has written and illustrated many popular children's how to draw in 3-D books, published and distributed around the world, including *Mark Kistler's Draw Squad* and *Learn to Draw with Commander Mark.* His book *Mark Kistler's Imagination Station* is published by Fireside and is available in bookstores nationwide. His third book, published with Fireside, is titled *Drawing in 3-D with Mark Kistler* and is available in bookstores everywhere.

Over 600,000 visitors have hit his web site at www.draw3d.com. This cyber art academy teaches kids around the world how to draw. Visit museums, chat with famous authors and illustrators, and safely explore the imaginative world of the World Wide Web!

## Mark Kistler's Imagination Station . . .
## Classroom Video Series

Sixty-five half-hour "Learn to Draw in 3-D" lessons reedited from the national public television series for teacher resource sets and student library checkout sets. This sixty-five-lesson video series will guide your class through an enchanting voyage of creative discovery. Millions of students have learned how to draw in 3-D with Mark Kistler videos . . . yours will, too!

# Mark Kistler's Imagination Station
## Learn to Draw in 3-D with Me

Get your students prepared to blast off into the land of imagination with pencil power! For seventeen years, Mark Kistler has been teaching kids how to draw in 3-D with this world-famous assembly program. An unforgettable hands-on assembly that encourages students, teachers, and parents to participate. Kistler has taught 30 million children around the world how to draw. He can teach your students, too!

Mark Kistler deeply believes that learning how to draw in three dimensions builds a child's critical-thinking skills while nourishing self-esteem. His positive messages on self-esteem, goal setting, dream conquering, environmental awareness, and the power of reading have sparked millions of children around the world to discover their awesome individual potential.

## Here's What You're in For

- Two enchanting live performances with Mark Kistler.
- One assembly for grades K–2, and another for grades 3–6.
- Fresh new lessons each year!

Students arrive at the assembly equipped with paper, pencil, and a book to use as a lap desk. Mark Kistler has the group (up to 5,000 at a time!) sit on the floor poised and ready for drawing action. Students complete four 3-D drawing lessons, get introduced to the Internet cyber art academy, and get inspired to illustrate their own great American novel!

At the conclusion of the drawing lesson, Kistler encourages the children to explore specific fun children's web sites on the Internet. Children can now mail, fax, scan, and modem their drawings into student art gallery web sites. Their drawings will be displayed in international cyberspace for all the world to see and applaud. Students and teachers are invited to visit Mark Kistler's web site at www.draw3d.com.

Your school will also receive four of Mark Kistler's Drawing in 3-D video lessons for two hours of classroom follow-up instruction. Schools are encouraged to duplicate this video for additional library checkout copies.

Using an overhead projector, television/VCR, chalkboard, and microphone, Mark Kistler guides your children through an extraordinary imagination adventure. Your students learn how to draw in 3-D while Kistler tells stories of great galactic adventures, journeys to the bottom of the sea, time-traveling odysseys back to the land of the dinosaurs and forward into time with pencil power. This "how-to-draw" assembly is an experience your children will never forget.

To schedule a Mark Kistler program, or to get more information on other Mark Kistler programs available, call 888-UDRAW-3D.